PRECIOUS SOULS

PRECIOUS SOULS

A journey into the inspiring lives of
special children and their families

Dr Anantha Krishnan M.

From the bestselling author of
A Different Spirit

PARTRIDGE
A Penguin Random House Company

Copyright © 2016 by Dr Anantha Krishnan M.

ISBN:	Hardcover	978-1-4828-7063-3
	Softcover	978-1-4828-7062-6
	eBook	978-1-4828-7061-9

All rights reserved. No part of this book may be used or reproduced by any means, graphic, electronic, or mechanical, including photocopying, recording, taping or by any information storage retrieval system without the written permission of the author except in the case of brief quotations embodied in critical articles and reviews.

Because of the dynamic nature of the Internet, any web addresses or links contained in this book may have changed since publication and may no longer be valid. The views expressed in this work are solely those of the author and do not necessarily reflect the views of the publisher, and the publisher hereby disclaims any responsibility for them.

Print information available on the last page.

To order additional copies of this book, contact
Partridge India
000 800 10062 62
orders.india@partridgepublishing.com

www.partridgepublishing.com/india

Part of the proceeds from the sale
of this book will go to the
Inspired Indian Foundation (IIF),
a writers' movement celebrating
the success of unsung heroes.
IIF is spearheaded by the author.

www.inspiredindianfoundation.org

Precious Souls was originally a series anchored by the author in *The New Indian Express*. The author has obtained written permission from the Executive Editor of the paper (July 2, 2014, via email) to reproduce the articles and photos in a book form. The stories have been re-edited and a few more chapters added to suit the book format.

Photos: Jithendra M.
Cover Image: Renjith C. Thalavoor
Cover Design: V. Jayaprakash

This is a painting by
Diwakar Bhaskar, a
child with special needs.
The author drew inspiration
from this painting
while putting the book together.

Precious Souls is
dedicated to

* Mothers who have sacrificed
their lives to bring up
their children with special needs.

* Teachers, trainers, and institutions
who are supporting the cause of
special children and their needs.

Awaiting You

Part I

Great Attempt to Create Awareness 3
Please Understand Us 5
Author Foreword
#MissionPreciousSouls: An Emotional Endeavour 7

Part II

Sublime Lines ... 17
Joyous Melodies ... 21
Musical Miracle ... 25
Blessed Bliss ... 31
Twin Delight .. 35
Mama's Darling ... 39
On Song .. 43
Beautiful Mind ... 47
Mighty Strokes .. 51
Sporty Spirit .. 55
Million-Dollar Genius 59
Classical Gem ... 63

Hope Chaser ... 69
Dream Drummer .. 73
Rewriting Destiny .. 77
Summing Shades .. 83
Mellifluous Strings ... 89
Unchaining Ambition .. 95
Little Treasure .. 99
Living Absolute ..103
Unbreakable Will ...109
Finding Life .. 115
Happy Hope ... 119
Conquering Challenges ... 123

Part III

Capturing Precious Souls131
A Metaphor for Triumphant Lives135
My Experiences with the Special Children139
The Last Word ...143

Part IV

About the Author ...147
Inspired Indian Foundation149
Billion Beats ...153

Part I

Great Attempt to Create Awareness

I am glad to see the book *Precious Souls: A journey into the inspiring lives of special children and their families,* written by Dr Anantha Krishnan M. These are not stories of great achievements. These people haven't done anything that will appear extraordinary. All that they have done is not to allow their disabilities to limit their freedom and the power to dream and excel. This book by Dr Anantha Krishnan M. brings to you the lives of twenty-four inspiring souls, and he has done a great job.

It has been interesting to read the story of Chottu (Samarth) and his love for math and painting. The tribute by his mother—'From him, I learned what true love is. I am his student first and then his mother'—is very inspiring.

There are thousands of *precious souls* around us. We see them, pass by them, but hardly take the time and effort to understand and appreciate them. All they need is a little push, a nod of understanding, or a smile of appreciation.

I hope this great attempt by my journalist friend will create awareness among people about special children, their needs, and their gifts.

My best wishes,

Dr A. P. J. Abdul Kalam
Former President of India
10, Rajaji Marg,
New Delhi 110 011
11 February 2015

A Special Child's Message

Please Understand Us

Stuti Sarkar

Be positive. Do not lose patience. Try to understand us. Every tantrum has a reason; try to find them. Always respect us. We have the same feelings, but our way of expression is different. We have problems in processing the information we receive from others around us. We have abilities—try to find them. We need lots of help from others, so let us please do it together.

Twenty years ago, autism was hardly heard of. When I was diagnosed with autism, my parents faced a lot of problems. Nowadays, the society is more considerate towards us. We are struggling with situations every moment of our

lives. Everyone is confused with our behaviour. But they do not know the troubles we face. Our body is like a car. When the brakes work well, we are able to control ourselves. When they fail, we lose our control and throw tantrums.

People call us disabled, but I think no one is fully abled. I believe that all of us are God's children, and we are all the same.

I want to tell everyone to please understand us. I still feel that we are not accepted in the society.

I wish for a society where each one of us is treated equally. I look forward to a day when we also get a chance to stand next to others and not at the end of the line.

- Read Stuti's story on Page: 77

Author Foreword
#MissionPreciousSouls:
An Emotional Endeavour

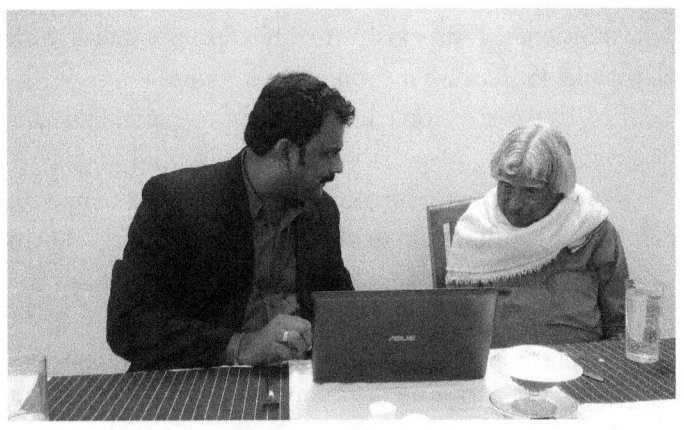

The author shares a draft of *Precious Souls* with Guru Kalam.

It was just a happy coincidence that I sat down to pen this chapter on Mother's Day in 2015. Ever since my mother, a retired English teacher, left for her heavenly abode in 2007 at the age of sixty-five, she has been a silent but sure presence in every step I take. I bow before her before I begin the day, before I begin something new.

The idea of *Precious Souls* took birth in the newsroom during an editorial meeting. First week of August 2013, and a brainstorming session for Independence Day edition was underway. After much discussion and deliberation, it was decided that I would anchor a weekly column dedicated to special children and their families.

My association with the special souls had started earlier with Inspired Indian Foundation. My feelings towards them were strengthened further after my experiences from my first book, *A Different Spirit*, and its subject, Olympic paraplegic athlete Malathi K. Holla, who runs the Mathru Foundation.

Additionally, my visits to the Spastics Society of Karnataka (SSK) gave me some rare insights.

I had a week to come up with the first piece, and thus began my search for special souls with inspiring stories.

Through my friend Sai Ramesh, I had come in contact with Sajinie Gnanatheeban, principal of Baldwin Opportunity School, Bangalore. I shared the idea of *Precious Souls* with her.

She put me through to the first couple, Bhaskar and Saraswathi. Their son Diwakar Bhaskar was a ten-year-old when I met him. Diwakar, in many ways, continues to remain my inspiration. His flower painting became the logo for the series, and the first article itself managed to grab the attention of readers.

Soon after, we started a Facebook page (https://www.facebook.com/theprecioussouls) for *Precious Souls*, which did wonders for the series, and soon we got attention from India and abroad.

Vidya Venkatesh, mother of gifted pianist Adithya, is another person I am indebted to. She has been instrumental in keeping my mission alive, initially connecting me to families with special children.

Precious Souls, in many ways, is about mothers as well. I was moved by Vidya's response when asked about bringing up Adithya. 'Nights leave me with a lot of disappointments,

but every morning I wake up with renewed hope. I know, one day I will succeed. I know I will.' She embodies the hopes and aspirations of all mothers with special children.

SSK played their role in promoting the idea of capturing the lives of special souls and their families. During one of the carnivals held for special children, SSK offered us a free counter to meet with parents who were eager to share their stories.

Sujatha Sriram, a special educator from Chennai, happened to hear my speech on the media's role in creating an inclusive society during an event held in Bangalore in November 2013. Since then, she had been a constant source of encouragement and had also written a chapter for this book.

The person who gave me the idea for this book was V. Sudarshan (then the executive editor of *The New Indian Express*), now the resident editor of *The Hindu* in New Delhi. 'Man, this is a great concept, and this should be your next book,' he had told me while relishing fish *tava* fry at one of his favourite hangouts in Bangalore's Indiranagar area.

I would like to thank my former colleagues at *The New Indian Express*, Bangalore, who backed my mission.

In the last fifteen years, ever since I first met Dr A. P. J. Abdul Kalam, he has been my guiding force. When I handed over the second draft of the book in mid-January 2015 to Guru Kalam at Raj Bhavan in Bangalore, I was delighted to see him ask his long-time trusted aide, R. K. Prasad, to keep it inside his suitcase. And as promised, he wrote his views on the book after going through each chapter.

I am deeply saddened that he had left us before the book could be released. Though he stayed away from book-release events, he had promised to attend the launch as a special

case. 'You email me. I will definitely try,' he told me during our last meeting in June 2015.

Dr Kota Harinarayana, top aerospace scientist, for all the motivation in my various pursuits.

My cousin Simmi Santha, a behaviour therapist based in Canada, played a part too in the making of *Precious Souls*. Reconnecting with her after two long decades had truly been propitious as her invaluable inputs played a crucial role in the shaping of the book.

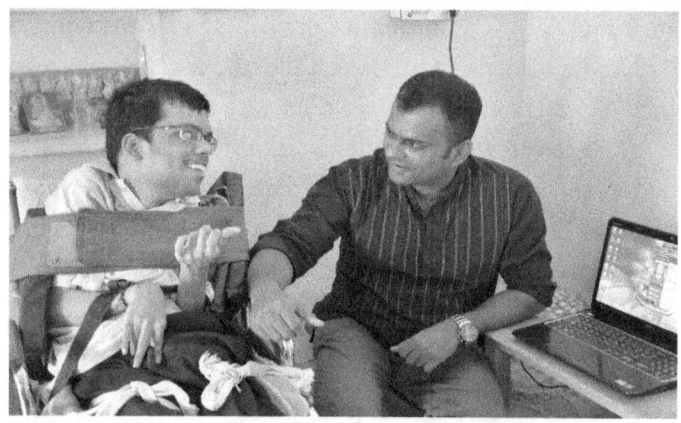

The author with Avinash Sonnad, who suffers from cerebral palsy, during an interview session for *Precious Souls*.

The shutterbug in M. Jitendra has been phenomenal. In over two decades in journalism, I haven't come across a photojournalist who is as understanding and patient. Jithu, as we fondly call him, has had his share of tough moments as well. Not one to give up, he has ensured that we have the best shots. I have let him do all the talking about our experience in meeting these precious souls in a separate chapter (part 3).

Jose K. George, a soft-spoken copy editor, readily agreed to be my research assistant in the *Precious Souls* project. He would often sacrifice his weekly offs for re-editing the stories and ensured that we stuck to our weekly schedules of the project.

I am thankful to G. Krishnaswamy, former news editor of *The Times of India*, who has been extremely supportive. His final touches and observations have refined the book.

VP, one of the finest news desk hands I have come across, for the invaluable contributions to the final draft.

Aaron Mathew, a budding creative writer and Reshma Balakrishna, a communication professional for their suggestions.

My friends V. Geethanath, Dr Gautham Machaiah, Sam Varghese, Manoj Pillai, Santhosh Thampi, Arun Murthy, Veena, Raji, Dr Uma Devi and Dr Sapna M. S. for passionately backing up all my creative pursuits. My childhood friend Manoj Kumar B. for being a silent force all through my life.

Artist Renjith C. Thalavoor for creating the image for the cover design of this book at a very short notice.

V Jayaprakash, an ace graphic designer, who conceptualised the cover for the book.

Former colleague Vyas Sivanand, who felt an emotional connect with the subjects of *Precious Souls* during various stages of his involvement at the newsroom and during the making of this book.

I am obliged to every parent who has been featured in this book, for they have made this mission possible. When I emailed about the book plan to all parents on 31 October 2014, the response was overwhelming. Again, an update

mailed on the book's progress on 13 May 2015 was met with much enthusiasm.

I am thankful to my close family members and well-wishers, who have stood by me in all my adventures in life.

The interviews for *Precious Souls* have been done between August 2013 and April 2014. The age, education, and profession (in some cases) of the people featured in the book have not been updated to the current period. Location of families and certain schools has been omitted following requests. Words related to Indian culture have been explained for the benefit of global audience.

The medical history and other information regarding the special souls have been provided by the parents.

For the hardcore aerospace and defence journalist in me, spending hours with the families of special souls had been an unforgettable, moving experience. There were moments when I could feel the pain of the mothers and the moving silence of the fathers.

There were instances when some parents requested not to mention many details about the siblings of a special child. Some objected to taking photos, while some others spoke on condition that the draft would be shown to them before it went to print. I am delighted to say that many of the people featured in the series continue to keep in touch with me.

I am grateful to the Partridge India team from the Penguin Random House company, who interacted with me during the production phase of *Precious Souls*. My publishing services associate Pohar Baruah for going the extra mile to make *Precious Souls* better.

I also thank the millions of followers of my aerospace and defence blog, Tarmak007, from across the globe, who have been supporting all my writing missions.

#MissionPreciousSouls has been a tough assignment but is also packed with many surprises, emotions, and learning. I will be glad to have your feedback, which can be mailed to anantha.ak@gmail.com or anantha@inspiredindianfoundation.org. You can also reach me at +91-98451-98458.

Similar to my first book, part of the proceeds of this book goes to Inspired Indian Foundation, which supports unsung heroes.

Finally, offering my *pranams* to all my gurus in journalism, my parents, and the Almighty.

Be inspired by *Precious Souls*, and let's strive to create an inclusive world.

Bangalore Dr Anantha Krishnan M
11 November 2015

Part II

The journey into the world of special children and their families has been presented in a narrative style. In this section, you will be experiencing their lives and triumphs right in their homes from across India.

*'It was only a few months ago that he called me Amma [mother].
It was indeed a special moment,
one that I had been waiting for years.
It means the world to a mother.'*

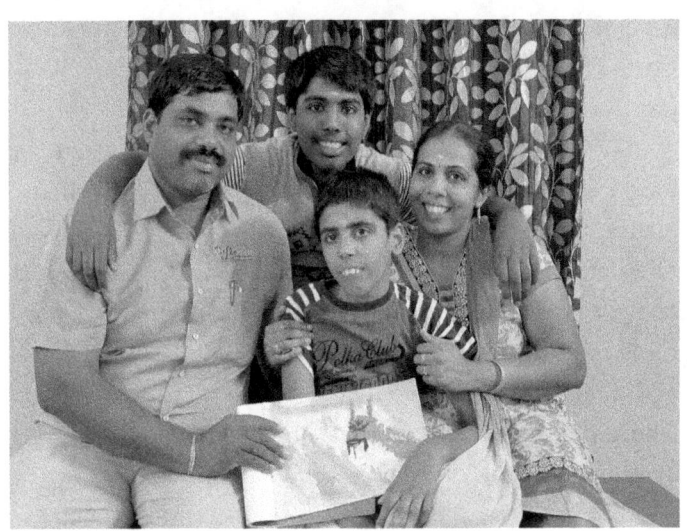

Sublime Lines

Diwakar Bhaskar.
On paper he imagines. In colour he lives.

Ten-year-old student of Baldwin Opportunity School, Bangalore, Diwakar enjoys painting. His favourite colour is red; he also likes green and, sometimes, yellow. And he loves Carnatic music.

Born to R. Bhaskar, a businessman, and Saraswathi, a housewife, Diwakar was diagnosed with maple syrup urine disease (MSUD), a metabolic disorder passed down through families in which the body cannot break down certain parts of proteins. Urine of people with this condition can smell like maple syrup.

For the first two and a half years of his life, Diwakar never walked. He did not roll over, smile, or utter a single word. He was merely lying on the bed, staring at the ceiling, just like a newborn baby.

'We realised the gravity of the problem when we took him to the National Institute of Mental Health and Neurosciences (NIMHANS), Bangalore. We were told that Diwakar was a special child. Had he been diagnosed soon after he was born, he would have been a normal boy now. Early intervention is the key,' says Bhaskar.

'The doctors told us that his is a one in a lakh case. The proteins in food we gave him, without realising his condition, damaged his brain cells,' Bhaskar adds.

Today, Diwakar smiles, walks, and even talks a bit. He is able to make eye contact with his mother. His neck is getting stronger. But he can be moody at times.

Saraswathi is happy as Diwakar is able to understand simple instructions. She is delighted to see her son beginning to enjoy the freedom that other children of his age enjoy. 'I was upset when doctors told me about our son's condition. I cried a lot. That day, my husband was away, and I knew I could not allow emotions to take over me. I needed to be strong and stay positive,' Saraswathi recalls.

'It was only a few months ago that he called me Amma [mother]. It was indeed a special moment, one that I had

been waiting for years. It means the world to a mother,' she says.

Diwakar opens the door for you, closes it, gets you plates. He is beginning to adjust to normal life, but he needs appreciation for every little task he performs.

'We don't treat him as a special child, and we are very proud of him. We take him to all functions, and many of our relatives are happy and surprised to see how he has improved,' his mother says, brimming with pride.

Diwakar's best friend is his elder brother, Rahul. When Diwakar gets angry, he rips apart Rahul's textbooks, but Rahul's calm demeanour has a huge impact on his brother.

Bhaskar says that many parents are hesitant to speak about their children diagnosed with developmental disorders. He feels that there is a need to create awareness about special children. 'There should be better coordination among parents who have special children,' he adds.

Diwakar's school plays an important role in his life.

Sajinie Gnanatheeban, principal of Baldwin Opportunity School, says that special children are blessed with the gift to forgive and forget.

Sajinie has been dealing with special children for more than twenty-one years. 'They are very cheerful and patient. Their love is unconditional. Unfortunately, not many are able to understand and appreciate these children. There should

be more job opportunities created for them when they grow up,' she says.

Diwakar is on a special diet—no milk, cereals, meat, or eggs. 'We all turned vegetarian for him. He comes and smells everything. He wants to make sure that we are not eating anything different. It is little sacrifices like this that makes the world a bit more beautiful,' Saraswathi says.

And while Diwakar gets back to his world of colours, he knows there are people living for him.

*'First we have to accept the reality,
which might take some time.
Most parents go through different levels
of acceptance. Earlier the better.'*

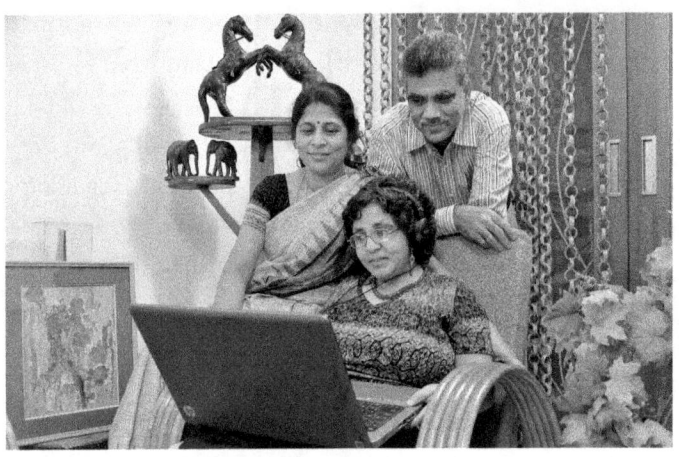

Joyous Melodies

Sushmitha Danabalan. When ruin
was within, she embraced life.

A mellifluous chorus of lovebirds greets visitors at the fourth-floor apartment of Sushmitha. Thirty-four-year-old Sushmitha has her headset on, and her favourite playlist is ready on the laptop. She wears a smile of content.

She looks with amusement at photojournalist Jitendra as the camera goes on a shooting spree. Her father, T. L.

Danabalan, a retired Indian Space Research Organisation (ISRO) deputy director, recalls how Sushmitha has made a PowerPoint presentation on their marriage anniversary. 'Wedding anniversary', says Sushmitha, a childlike delight flooding her face.

Sushmitha's physical condition was not at its best when she was young. When she was enrolled for LKG at four and a half years of age, her auditory learning was normal, but she had developmental delays when compared to other children of her age.

'She was a student of Poorna Prajna, which was very kind to admit her along with other children. Her doctor [Shobha Srinath, child psychiatrist at NIMHANS] used to visit her school to explain to others about this child's abilities and disabilities. She was recommended speech therapy and physiotherapy,' says Mala, her mother.

With the support of her teachers, she was provided a scribe to write her exams. 'But she had difficulty coping with regular schooling, and in 1990, while she was in fourth standard, she was shifted to Spastics Society of Karnataka [SSK],' Mala recollects.

Mala says attending a diploma course in special education in 1989 has been the turning point in her life.

'It was an eye-opener, and I did it to support Sushmitha. Talking about my feelings with others really did wonders. I realised that I am not an island and there were many others sharing my journey. Until Sushmitha was taken to NIMHANS, the doctors who treated her always said that she would be okay when she grew up, and we believed it. Early intervention is the key, and I want all the parents to keep this in mind,' adds Mala, a psycho-educationist.

At SSK, Sushmitha honed her vocational skills, which gave her confidence to face the world. She also fine-tuned her psychological needs and channelled her creative outbursts. She took part in walkathons and even successfully completed her class 10 board exams conducted by the National Institute of Open Schooling.

She then underwent training as a front desk staff. Sushmitha then mastered computers and completed a certificate course in computer applications as well. A two-year intensive training in library management also kept her busy.

Sushmitha's father, Danabalan, admitted that initially, he was shocked when his daughter was diagnosed with health issues.

'I want every parent to treat such children as a God-given gift. She surprises me every time when she remembers the birthdays of our close relatives. She reminds me exactly a day early so that I buy them a gift. Sushmitha is a very sweet child. Her endurance levels are very high, and she is very obedient. She is very fond of her brother [working abroad], and whenever he comes home, she gets him chocolates from her office canteen,' says Danabalan.

Sushmitha has been employed with Sasken Communication Technologies Ltd for the last twelve years as a library assistant.

'She is very punctual and very regular to office. She loves her job. She has a

specific time for everything, including listening to music. She has a good collection of Tamil, Kannada, Hindi, and Telugu songs. She loves painting and never misses an opportunity to go on long drives,' says her mother. Sushmitha is also a recipient of the Karnataka State Women's Achievement Award 2009.

And here's what makes her truly a precious soul! For the last twelve years, a part of her salary goes to sponsoring the education of a differently abled student. She signs the cheque and accompanies her mother to personally hand over the same to SSK.

'Systematic training and family support will definitely make a change in the lives of differently abled children. First we have to accept the reality, which might take some time. Most parents go through different levels of acceptance. Earlier the better,' says Mala.

For Sushmitha, embracing life has begun early, and life has indeed cuddled back.

*'As a mother, I had my bad days of trying
to adjust with him. But not for once
did I give up during the last fifteen years.'*

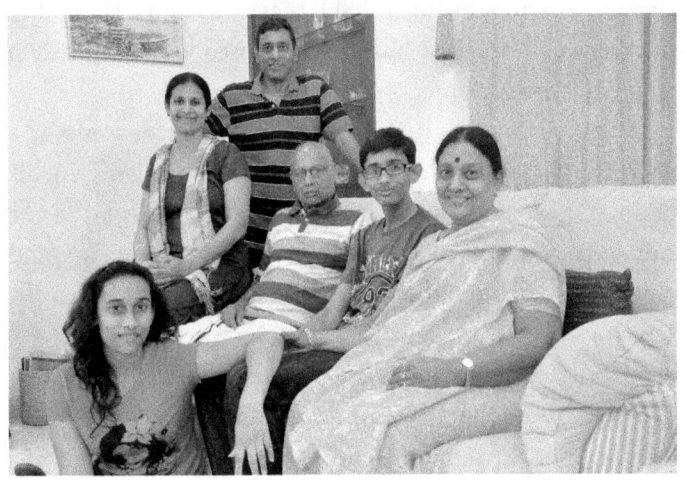

Musical Miracle

Adithya Venkatesh. He heard the rugged sound
and tamed it into a beautiful tune.

'Do you like music? Can you play like me? When is your birthday? Where's your house?' A volley of questions greets us as we step into his flat.

The whirring sound of a chopper catches the attention of bespectacled fifteen-year-old Adithya, a student of Chrysalis High, a regular school with an inclusive set-up.

'Every day it comes and goes. Every day,' he says, looking at the chopper.

Hardly anything about this enthusiastic youngster, who has a deep love for Carnatic music and has over twenty music concerts to his credit, tells you that he is suffering from pervasive developmental disorder (PDD), a type of autism spectrum disorder (ASD) that slows down the ability to perceive things. Adithya was diagnosed with PDD when he was set to turn three.

'Ten years ago, we had no idea about autism. The doctors told us that there was some sensory issue in his brain. We were not sure what caused this. We started the treatment with speech therapy, communication therapy, and sensory integration among others,' says Adithya's father, R. Venkatesh, an entrepreneur.

Until he was four and a half years old, Adithya was on epileptic medication, owing to a mild seizure he suffered when he was three months old. He never smiled, reacted to anything, or spoke. His eye contact was poor. 'My birthday is on April 26. I make birthday cards for my father and mother every year,' Adithya cuts in, eager to join the conversation.

'We were clueless. He did not have any major behavioural disorders, but sometimes, he would just fall flat on the ground to get our attention and even bang his head on the ground. He had severe constipation, which would continue for days,' recalls his father.

Growing up, the young boy suffered much due to fungus growth on his body. He had warts on the body, and his intestines were totally damaged. He was put on a strict GFCFSF (gluten-free, caesin-free, and sugar-free) diet. He was kept away from wheat, sugar, and dairy products.

'Going to birthday parties was difficult as Adithya could not eat with abandon. But he was always patient,' says Adithya's mother, Vidhya, who left a promising career in fashion design to support him. She learned music, swimming, badminton, and horse riding—all for Adithya.

'His handwriting started improving. He could write four sentences in one big page. He loved music,' Vidhya says.

The family found a ray of hope when his parents took him to Aashwasan, a special-needs centre, when he was eight. He responded better to this new mode of holistic treatment. 'As a mother, I had my bad days of trying to adjust with him. But not for once did I give up during the last fifteen years,' says Vidhya.

'When he was four, he played the nursery rhyme "Baa Baa Black Sheep" on the keyboard and gently smiled at me. This is when I realised he enjoyed music. He never referred any books or notations. First he learned Western classical and then switched to Indian classical. I knew this was God's rare gift to him,' recalls his mother.

As a kid, Adithya used to listen to classical music for hours. 'While his mother was away, working, I could manage him by playing him songs. He would be quiet as long as the music was on,' says Rajagopalan, Adithya's grandfather, a retired Indian Telephone Industries Limited (ITI) director.

According to Adithya's grandmother

Sukanya, he likes listening to renowned Carnatic vocalist Unnikrishnan. Sukanya says Adithya loves the opening music of the hugely popular television programme *Kaun Banega Crorepati* (KBC), India's version of *Who Wants to Be a Millionaire?*

He had his first major concert at the age of seven at Karanji Anjaneya Temple. His musical talents have impressed many, including his *guru*. 'His immense interest, dedication, and concentration have always touched me. His efforts while learning and expressions while playing the keyboard are remarkable. Music is his world,' Adithya's guru, Tirumale Srinivas, praises on his special disciple.

For his sister Ishwarya, Adithya is a selfless soul with boundless energy. 'Initially, I was jealous because of the attention he used to get and was even hostile to him. But he moved me with his patience and sweet nature. He is indeed an inspiration to me,' says Ishwarya, a second-year engineering student, who adores her brother.

Adithya had an opportunity to meet renowned Argentina-based flautist Pablo Salcido, who visited India recently. Salcido visited Adithya, and the duo had a *jugalbandi* (a performance in Indian classical music featuring a duet of two solo musicians) of sorts, says his father Venkatesh. 'Adithya has changed our lives. He taught us to appreciate small gifts in life. He brought us all together. Today I am more attached to my parents, thanks to my son,' says Venkatesh.

Adithya's mother admits that despite her son's increased abilities, every night continues to be an ordeal. 'The nights leave me with lots of disappointments, but every morning, I wake up with a renewed hope. I know, one day I will

succeed. I know I will,' avers his mother, who is not someone easily beset by disappointments.

As we are nearing the end of our conversation, Adithya is ready with a song. He wants to play *Nagumomu kanale*, the famous *Abheri raga* in Carnatic music.

Melody knows it has been tamed by him, and no wonder the magic in his music enchants.

*'She came to my life when I was forty-one.
But I count myself lucky as
I still have the right kind of
people around, who support me.'*

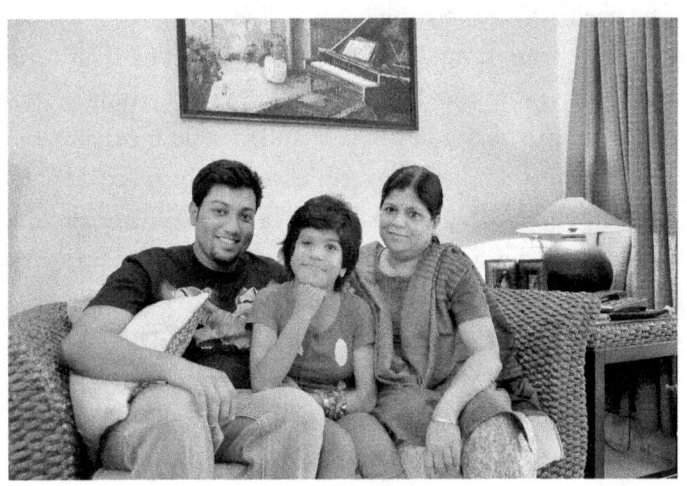

Blessed Bliss

Ragini Bose. When life asked her
name, she said, 'Courage'.

'My best friend is Aranya. I have another friend, Anya, and she wears glasses. My mother bought me a pink salwar kurta on my birthday. I like pink. I have pink shoes.' Twelve-year-old Ragini is all excited. She poses for photos, hugs her brother Nikhil, and whispers something in his ears.

'The photo uncle is good,' she tells her mother but was soon lost in thought. She is trying to recall her favourite song. 'Think. Think. I am thinking. I forgot,' she says. 'Geethakka loves me and takes care of me.' Her thoughts and words flow in no particular order.

When Ragini was three and a half months old, she was given DPT vaccine, and she began throwing up for days. The paediatrician treating her was clueless.

'She came to my life when I was forty-one. Until she was fifteen months old, she would vomit everything. Later, I took her to a doctor in Kolkata, and she told me that it was a miracle that the baby was still alive. She instructed me to hold the child upright when I feed her. It was difficult. She would often wriggle out. And she would throw up every time the posture was changed,' her mother, Gopa, a teacher at Steiner School, where Ragini is a fourth grader, recollects.

Despite her poor health, Ragini was a happy and cheerful child. 'She started sitting up and walking late. She began walking only when she was nineteen months old. Her movements lacked balance. Certain parts of her body were extremely sensitive. By the time she turned two, I sensed something was wrong,' says Gopa.

Ragini was comfortable inside the house, and she could relate to the objects she dealt with daily. But she couldn't handle the unfamiliar, anything that was outside the house. She could not even walk on the grass.

'When she was four, we even did a chromosomal test. It was during this time that I attended a seminar conducted by Dr Lakshmi Prasanna. Many of my questions were answered there. It was as if she were talking about my daughter. I met

Dr Lakshmi later, and she gave me a few valuable suggestions which have helped me immensely,' Gopa says.

What makes her more worried is the fact that the exact cause of her daughter's illness, referred as delayed development, is yet to be found.

Ragini's speech is not focused, but she follows conversations well. She has a few gifts too—she can paint, dance, and clay-model. Her watercolour paintings are kept neatly bound, and no visitor misses the piggy bank she has made out of clay. 'I love piggy. Piggy. Piggy. My piggy,' Ragini says as she drifts off to sleep. It is 6 p.m., the time she goes to sleep every day.

Ragini is an affectionate sister to her brother Nikhil. 'She strikes a chat with every person she meets. She is really sweet. Ragini dances non-stop every time I play the piano. Her movements are very coordinated and graceful. She will soon be enrolled for a dance class,' he says.

Of course, she has her share of mischief as well. 'She has torn a few of my study materials, including my report card. But I do not yell at her,' says her brother, a final-year engineering student.

For Gopa, life has been a lonely battle after she was separated from her husband in 2011. 'The last two years have been tough. Ragini asks for her father, and it is difficult for me to come up with reasons for his absence. She misses her father. But I count myself lucky as I still have

the right kind of people around, who help and support me in my struggle.'

Her daughter is an inspiration to her. And in courage, Ragini generously gives hope.

*'Support from the family makes a world of difference.
What happened to my daughters is unfortunate.
But we have managed to rise above the disappointments.
We are happy to make sacrifices for our girls.'*

Twin Delight

Nandita and Smita Rao. Together, challenges
they face, and together they rejoice.

Nandita loves red bangles. Smita, her elder sister by thirteen minutes, loves green ones. M. S. Dhoni is Nandita's favourite cricketer, while Smita likes only sixers. Smita is fond of

Bollywood actress Aishwarya Rai, but Nandita says actor Saif Ali Khan is the best.

You will never have a dull moment in the company of these thirty-seven-year-old twins, neither can you leave their house without being photographed. 'If you want, I will click another one,' Nandita chimes in. The twins love their camera.

Their parents observed hyperactivity in the twins when they were ready for primary school in Delhi. Medical examinations confirmed that the twins had health issues. However, they were admitted to the Army Welfare School.

'I had a transferable job. In 1983, my wife decided to come back to Bangalore along with the kids and join the Sophia Opportunity School. Later, in 1990, the girls were shifted to a special school,' says their father, Wing Commander B. R. Madhava Rao (retd), a veteran Indian Air Force engineer and specialist in MiG-21 types of aircraft.

The girls learnt embroidery, screen printing, painting, and stitching. 'Occasionally, they do some stitching even now. We have tried to make them as independent as possible. They can do a lot of things on their own, including fetching bread from the nearby store,' says a beaming father.

Both Nandita and Smita, suffering from moderate mental retardation, are good with computers and are employed at the Just Bake outlet managed by the Asha School of Indian Army. 'They are unable to travel by public transport. I regret not having trained them,' says Jyotsna Rao, their mother, a former teacher.

Their faces light up when Jyotsna asks them to sing a few lines. The girls love singing. For the next few minutes, a melodious *bhajan* (a devotional song in Hinduism) fills the

room, and we are spellbound. "Vara veena mrudupaani vana ruha lochana raani." The twins look at each other, nodding their heads in agreement, commending each other for a job well done. 'They love *bhajans*,' says their mother.

The twins adore their brother, now working abroad. According to their mother, the sisters keenly look forward to meeting him and playing with his children.

Nandita says she is an expert in solitaire. Smita loves listening to jazz on the radio.

The love these girls have for each other is sure to melt anyone's heart. 'They are inseparable. Smita is claustrophobic and doesn't take the lift. There are times when Nandita gives her company, climbing up even ten floors,' says their mother.

The family owes much to the teachers of the twins and to their relatives, admits Jyotsna.

'Support from the family makes a world of difference. What happened to my daughters is unfortunate. But we have managed to rise above the disappointments. We are happy to make sacrifices for our girls. I once took them to a theatre to watch *Hum Aapke Hain Kaun . . !* [a popular Bollywood film]. Smita got restless during the movie. That was the last time we went to a movie in a theatre,' she says.

The parents are worried about the future. 'It is going to be difficult for Nandita and Smita when we are no longer with them. They still have

no clue that one day we will have to leave. We hope our son will come back to India. We have a few plans in mind,' Madhava Rao says. They continue to hope that one day the twins will be able to live a normal life without having to depend on anyone.

It is time for the twins to have their daily walk, which they never miss. 'They walk inside the compound exactly for thirty minutes,' says their father.

And as they do, hand in hand, they reassure that there is bliss in togetherness.

*'Small things that he learns to
do make a big difference to us.
We try to stay positive and cheerful.'*

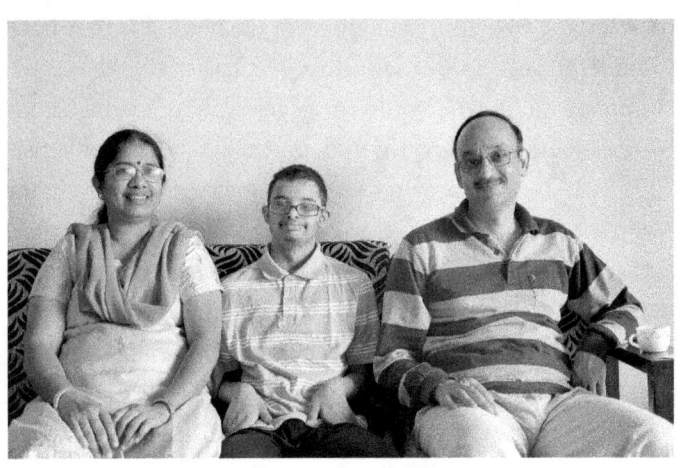

Mama's Darling

Hari Gokul. In his silence
he weaves a world of happiness.

Hari is recovering from a fever when we visit his house. His mother, Hemamalini, a former teacher, says that the sixteen-year-old has been very excited the previous night when he told about our meeting.

When his father, Dr Gokul Srinivasan, who works at an MNC, is getting familiarised with the *Precious Souls* concept, Hari serves us water. But he seems hardly interested

in us. The camera has grabbed his attention. 'He loves being photographed. He will pose for you however you want,' says his mother.

Hari has Down's syndrome, a genetic disorder caused by the presence of all or part of a third copy of chromosome 21, and has atrial septal defect (ASD), a hole in the wall between the two upper chambers of the heart. He may have to undergo surgery in the future. His father says that most children with Down's syndrome generally have several health issues, including heart, thyroid, and spinal cord problems.

Hari started showing signs of marked improvement when he came under the care of Vijaya Varadarajan, a therapist trained in Germany. 'His words and actions became more orderly. He even began understanding the concept of left and right and simple things like up and down,' says Gokul.

Later, Hari was shifted to Asha Kiran and then to Fame India.

He has been with the Asha School for the past four years. He is also undergoing music and speech therapy and is doing a pre-vocational course. His language skills have improved, he can write simple sentences, and his eating habits are normal; Hari is getting adjusted to the world slowly but steadily.

Hari is extremely silent most of the time and doesn't mingle much with anyone, and according to his parents, his activities are very much programmed. He is very time-conscious. He plays keyboard, is familiar with computers, and has even tried his hand at badminton. At 5.30 p.m. every day, he plays badminton with his mother. He loves the songs of Ilayaraja, the legendary Indian music composer

who works predominantly in the South Indian cinema, and watches cricket occasionally.

It takes a bit of prompting from his mother for Hari to tell us what his favourite food is: '*Pulav*. Like *pulav*,' he says. (Pulav is a spicy vegetarian dish popular in India prepared by cooking rice with various vegetables and spices.) But there is no hesitation when he is asked about his best friends. 'Mayank and Manikantan.'

Gokul has a very practical advice to parents with special children. 'Acceptance is the key when you have a special child. You shouldn't always be looking for cure for the child's problems, but make every effort to make your child independent. Parents with a special child worry about the child's future after they are no longer with him or her. If you have managed to make your child independent, you do not have to worry much about the future of the child,' he says.

'We celebrate every little achievement of Hari. He is our only child. Small things that he learns to do make a big difference to us. We try to stay positive and cheerful. We don't treat him like a differently abled child. For me, he is a normal child. This does not mean there are no challenges,' says his mother. 'He is more attached to his father because he doesn't scold him, so I am the bad cop in the house!' she adds.

According to Gokul, it is important to understand the choices, differences, and preferences of the special child. 'You also will have to make some adjustments and compromises in your life. You may

have to cut down on your social life in order to be with your child,' he says.

'You will have to think for two people all the time if you have a special child. It is difficult sometimes, but you have to do it,' says Hari's mother. She is never tired of being with him. 'I have no regrets,' she adds.

While Hari keeps himself engaged in his world, he gives a new meaning to the world of his parents.

'I have accepted my son the way he is.
I have learned a lot from him.
There are times I feel he is wiser than many of us.
He corrects me when I do some mistakes.'

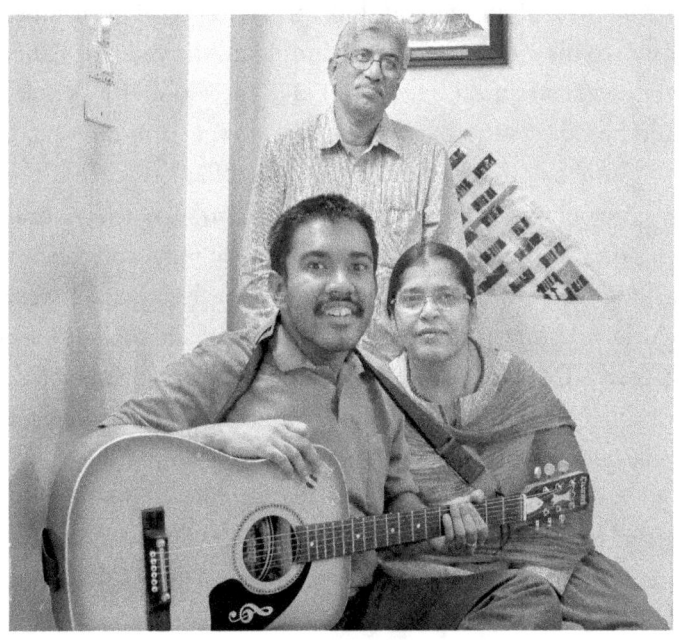

On Song

Anubhav Gopal. In music he finds himself.
In him they find the music of their lives.

Anubhav's best friend is eighty-four-year-old Devayani, his grandmother. He begins his day with a genial 'Good

morning' to her. 'My other friends are Monica and Zabi Ullah,' he says, his favourite guitar slung over his shoulder. Twenty-one-year-old Anubhav was diagnosed with autism when he was two and a half years old.

Anubhav is passionate about music. He memorises songs just by listening and can later mesmerise you with his mellifluous voice. His skills with the guitar and the keyboard will amaze you, but there is one rule: you must listen to his songs from the beginning till the end. He wants your total attention. He also likes to meet and visit people, and he expects those in his 'like list' to ring him up.

Anubhav is a student of SSK. 'Anubhav's teacher at the playschool was the first to observe some strange behavioural patterns in him. He used to stare at the light and fan for a long time. When she told us about the same, we were clueless. Until then, we had never heard of autism. We took him to NIMHANS,' recalls his father, Padmanabhan Gopal, working with Hindalco Industries Ltd. 'But Anubhav had very good eye contact,' he adds.

His mother, Anusuya, realised Anubhav's fondness for songs when she was singing him to sleep. 'His fondness for songs was clear from the way he used to react to the lullabies. He always wanted us to sing for him. We had this small tape recorder then, and we used to play a lot of Hindi songs for him. He started listening to Kannada devotional songs after he joined SSK. Later, he was trained under the late Uma Rao for seven years,' says Anusuya, a housewife.

'He loves singing at functions and enjoys the attention and appreciation it brings. He is into Rabindra Sangeet and Shyama Sangeet besides Hindi film songs. Right now he is learning Hindustani classical,' says his father. Anubhav is

also much sought after for his invocation songs. Listening to his dad talk about his fondness for songs, Anubhav begins singing "Nammamma Sharade, Uma Maheshwari", the famous Carnatic classical *bhajan*.

Anubhav miraculously survived a burst appendix when he was four. However, an unfortunate epileptic seizure he developed a couple of years back slowed him down on some of his extracurricular activities. But he is not one to easily give up; in addition to playing and singing known tunes, he improvises them and even composes fresh ones.

Music is not his sole passion. A wheelchair, a bicycle, photo frames, and a seven-foot-long scale—all of them made out of paper—capture the attention of visitors to his home, and his paintings adorn the walls.

Red is his favourite colour. 'My father bought me a red T-shirt,' says Anubhav. Even as the conversation continues, he cuts narrow strips of paper quickly with precision and makes shapes using adhesive tape. Triangle is Anubhav's favourite shape.

According to Anusuya, her son is not fussy, especially with food. 'He loves *appams*. We give him fish and chicken soup sometimes,' she says. (Appam is a type of pancake made with fermented rice batter and coconut milk.) She admits that it was hard for her to accept

the fact that Anubhav had some disabilities. 'Things have changed gradually. I have become more spiritual, and I owe it to my son. He sits quietly in the temple, holding my hands.'

'I have learned to accept things as they come. I have accepted my son the way he is. I have learned a lot from him. There are times I feel he is wiser than many of us. He corrects me when I do some mistakes,' his mother says.

His parents are surprised by some of the observations made by Anubhav, as he often listens to their conversations.

While the photo session is on, Anubhav plays "Kyunki tum hi ho" from the Hindi film *Aashiqui 2* on his guitar, his passion evident, focus rigid, missing the smiles he spreads around.

*'I am no longer worried about tomorrow.
Now I am both a father and mother to my daughter.'*

Beautiful Mind

Preksha Rajendra. In the puzzles of life,
she cracked every code.

Preksha is enthralled by the colourfully lit tall Christmas tree at the hotel lobby where our meeting is scheduled. The lights' changing into a new colour every few seconds amuses her, but her attention shifts soon to the cake shop next to the cafeteria.

'I want a chocolate cake. I want a chocolate cake.' The bubbly twenty-three-year-old girl has already made her

plans. 'After eating the cake, I will go in the car,' she says and repeats the same.

'Preksha is a foodie, and the best way to win her heart is to buy her what she likes,' her mother, Vani Rajendra, a former employee of State Bank of India, says. She now dedicates her time only to her daughter after the death of her husband, Rajendra, in 2010.

'Soon after Preksha was born, we moved to the United States. Four years later, in 1994, we returned to India, and it was then that she was diagnosed with autism spectrum disorder [ASD].'

ASD is characterised by persistent deficits in social communication and social interaction across multiple contexts and restricted, repetitive patterns of behavior, interests, or activities.

'Doctors in the US told us that she is merely having a normal delay in learning and speech, but that wasn't the case. Preksha wasn't making any eye contact. She was hyperactive, and her speech was delayed. She would often point at colours and shapes. I was not ready to accept her,' her mother recounts.

According to Vani, her husband helped her come out of the shock as he had already accepted their daughter as a special gift from God. 'God sent us one of his angels, he told me. Even now, when I am distraught, I close my eyes and experience His strength flowing into me,' she says.

Preksha was in a regular school until her second grade. Later, she was shifted to a special school as she was finding it difficult to manage the local language. 'She attended the special school until she turned twenty. She has improved much. She now has better vocabulary, her hyperactivity has reduced, and

now she sits down during meetings. She is able to socialise well,' says Vani. 'We have worked to improve her strengths,' she adds.

Rajendra had slipped into a coma following a cardiac arrest on the day Preksha celebrated her twentieth birthday, and his death left the mother and daughter traumatised. Thanks to her close family friends, who stood by them in their hour of crisis, they were able to gradually come out of the loss.

Like every mother with a special child, Vani also used to worry much about the future. 'The thought used to haunt me until I decided to take it one day at a time. I am no longer worried about tomorrow. Now I am both a father and mother to my daughter. She was very much attached to her father. Even now she sleeps at the same spot on the bed where my husband used to sleep,' Vani says.

Her parents were impressed by Preksha's liking for music and fondness for electronic gadgets. According to her mother, she used to try to sing every song she had ever heard.

'Music is like therapy to her, and there have been commendable behavioural changes after she started getting more involved in music. Maxi Priest's 'Close to You' is her favourite song. She also listens to Phil Collins, ABBA, and George Michael. She even loves the ghazals of Rahat Fateh Ali Khan, Ghulam Ali, and Jagjit Singh. She enjoys horse riding as well.'

Preksha can memorise 60 to 100 car numbers, their colours, and their make after seeing them just

once. She can also easily assemble 100-plus puzzle pieces in two minutes for the first time, and all subsequent successful attempts will be done in just a few seconds. Her favourite pastime is playing word-search games on the cell phone.

Preksha is a source of inspiration to everyone who knows her. She works as a software-testing specialist with SAP Labs. She leaves for her job by 6.45 a.m., taking the office shuttle, and returns by 7.15 p.m. 'She is committed to her job and does not entertain phone calls. When I call her sometimes, all she says is "Amma, can I speak to you later? I am busy now." She got the job with SAP in 2010 because of her ability to scan things really quick,' says her mother.

The job has worked wonders in Preksha's life. It has boosted her self-confidence and increased her verbal skills. 'She is an earning member of the family, and she is very much aware of this. Whenever I withdraw money from the ATM, she asks me why it is taken.'

Vani is of the opinion that parents of special children should be able to identify their strengths and work on improving them instead of worrying about their inadequacies.

'That will make life much easier. God may have withheld some of their strengths, but He has also blessed them with a few others. All that you need to do is to identify these strengths and work on to better them. Never lose hope and respect your special child just like you will do with a normal child. Never go by what others say. Never get worked up. There's no such thing as a dark side. I have proven it,' Vani says with a smile, exuding confidence.

As Preksha solves another puzzle and recalls another event, her mother is assured she will emerge a winner in life.

'To me, the bottom line has always been treating him like any regular child of his age.'

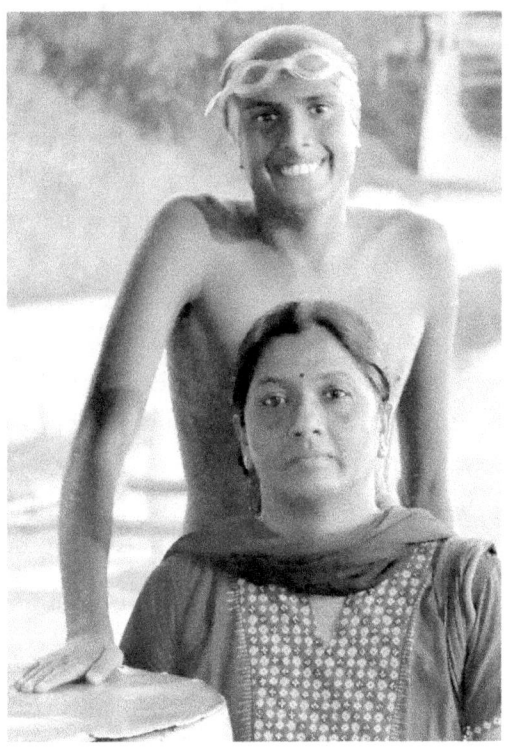

Mighty Strokes

Shashank B. M. When water whirled, he conquered.

Early-morning walkers are used to the sight of a young boy jogging with his mother following him on her bike. The

duo covers a distance of around two and a half kilometres in fifteen minutes to reach a swimming pool. This is their daily schedule.

Fifteen-year-old Shashank, diagnosed moderately autistic with attention deficit hyperactive disorder (ADHD), is a swimming champ with a cache of gold medals to his credit.

His parents began to notice delayed milestones when Shashank was three years old. He was a hyperactive child; his parents enrolled him to a summer camp to keep him engaged. He never mingled with anyone at the camp, prompting his parents to take him to the Bangalore Children's Hospital.

'It was a harrowing experience. We barely knew anything about autism. Ours is an extended family, and we took them into confidence before proceeding to take him for treatment. The doctor did a family counselling and also met each of our family members personally. My in-laws gave me the permission and freedom to deal with the situation the best way possible. All of us knew how to handle the situation, and this helped much,' Shashank's mother, Gayathri, says.

Gayathri recalls how she accompanied Shashank for his one-on-one therapy sessions in Malleswaram, often boarding two buses. According to her, these sessions helped the boy improve his interaction skills.

'To me, the bottom line has always been treating him like any regular child of his age. We underwent much pain while trying to get him admitted to a regular school. He has changed many schools until he got admitted to Mahatma

Children's Home run by Dr Sheshagiri Rao, a psychologist. He is doing fine in his studies,' says his mother, a housewife.

'I remember a teacher running to me once to say that Shashank was copying the notes, looking at the board. His rote memory is good,' says his mother. Joining the conversation, his father, Mahesh B. J., a businessman, says that Shashank is finding mathematics tough to handle.

His parents enrolled him for a basketball-coaching camp with the hope that this would help him learn team spirit. Despite being a good shooter, he could not identify his teammates and would often pass the ball to the opponents.

'So we decided to teach him swimming, and in January 2008, he took the first plunge into a pool. He fell in love with water and learned swimming within the stipulated twenty-one days. The head coach, John Christopher, was a great help. We are grateful to God for John's support,' Mahesh says. 'Seeing Shashank's skills, many special children have started swimming sessions now.'

Shashank's achievements speak volumes for his immense potential. He has earned a reputation in school and club-level swimming contests. He bagged gold in freestyle and breast stroke events at the Ministry of Youth Affairs and Sports Meet in 2013. At another national meet held in the same year, he bagged seven gold

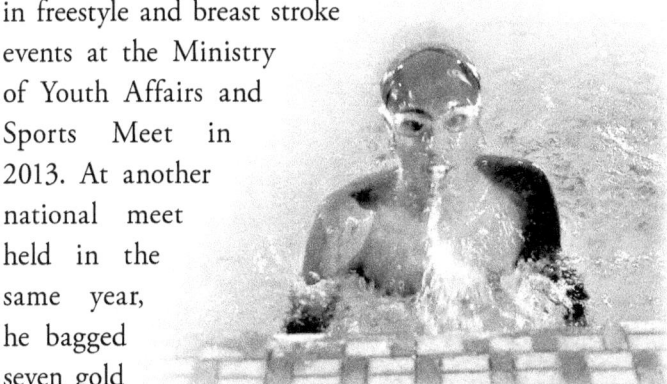

medals, a silver, and a bronze, and his overall medal tally is over fifty.

Shashank's six-year-old sister, Rithika, is his 'small mother.' When Rithika was born, Shashank was very curious about her and wanted to know all about his little sister. 'Their relationship is very special. He loves her a lot. She too takes care of him like a mother. When I am not around, she takes care of him just like I do,' Gayathri says.

Shashank joins the conversation when he realises that we are talking about his sister. 'My sister is learning Bharatanatyam. I want to learn drama. I wanted to become a pilot. But the aeroplane will fall down. So now I want to build a ship. I do not know what's inside it.' Shashank confides in us his secrets and desires. He enjoys watching plays.

'He is independent, and with little guidance, he can manage everything well. I am looking at the future with much optimism,' says his father.

So as Shashank emerges from the pool, having conquered the might in water, he looks ahead for more battles to win.

'Having a special child is not the end of the world. All that you need to do is to find the best ways to make the life of your child better.'

Sporty Spirit

Anand Honnavalli. When adversity knocked, he welcomed it, and together, they played badminton.

Anand goes to office by bus, hits the gym, enjoys sports, and even helps his mother in the kitchen. He is a normal twenty-five-year-old man.

Anand was diagnosed with Down's syndrome the day he was born, and his mother, Chaya Sudesh, was just twenty-three years old then. 'The gap between his big toe and small

toe was huge. His fingers were much smaller, and epicanthic fold was more,' says Chaya, a volunteer with the Children's Movement for Civic Awareness.

'I don't think I really understood when I was told that I have a child with Down's syndrome. The problems we would have to face in the future did not set in for the first few weeks after birth. But right from the beginning, my gynaecologist, my father, mother, and in-laws were all very supportive,' she adds.

Soon after Anand turned one, Chaya joined her husband, Capt. Sudesh Honnavalli, on the ship he was working and sailed to various countries. 'These trips really helped me. I realised that in foreign countries, awareness levels about special children are very high, and people are very supportive. Gradually, our confidence levels increased, and we started searching for solutions,' says the mother.

Chaya spent six months in the US when Anand was three and a half years old and started assisting a speech therapist as a volunteer. In 1994, Anand was admitted to the Bethany Special School when he was over six years old.

Anand was a popular student. 'The teachers loved him as he was really obliging. He used to assist his teachers till he completed his schooling in Bethany and even during his two-year stint with FAME India school,' says his mother.

Anand works at the housekeeping department of a leading luxury hotel. He is responsible for the distribution of uniforms to the staff. His superior, Pradeep Chandrashekhar, is all praise for Anand's dedication. 'He refuses to go home if there is any work pending. His memory is commendable, and hardly anyone can match his punctuality. We certainly have a lot to learn from him.'

Precious Souls

He travels to his workplace by bus all by himself. 'I give a ring to my mother the moment I board the bus and another after I reach the hotel. I call her again when I am ready to get back home. I have a Facebook account, and I love my friends. At times I fight with my sister, but I love her. I can understand her difficulties as well.' Anand's speech is slurred, but his thoughts are in perfect order.

He joins his grandparents for prayer and locks the back door for them every day. He even makes their bed. 'I watch all English movies. I am a big fan of Hrithik Roshan and have his photo on my cupboard. I work out at a gym. I have eight packs already. I also help my mother in the kitchen. You know, my life is all about music, and I love my drop shots while playing badminton.' Anand seemed to be in a mood to impress us.

Anand's nineteen-year-old sister, Aishwarya, says Anand is an extremely affectionate person. Aishwarya recalls some of the pranks she plays on him. 'Anand is very particular about keeping all his things at one place. Sometimes I hide his slippers just to see him searching for them everywhere. All my friends treat him as a normal person, and that's a huge relief for the family.'

Anand is an avid sports enthusiast; he

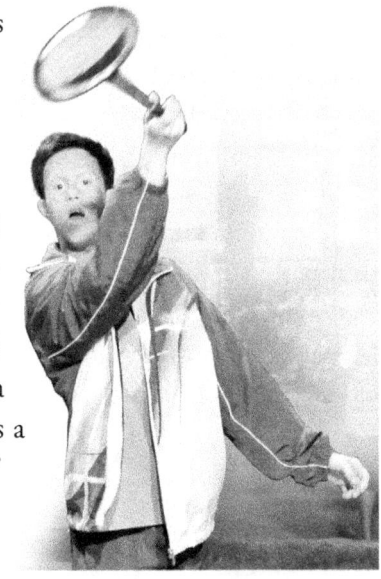

plays squash, basketball, table tennis, chess, and badminton and is a swimmer. Of late, badminton has caught his fancy. 'He won silver at the Special Olympics held in Rajasthan in 2009. In 2013, he went to Newcastle for the Asia Pacific Special Olympics and won three medals,' says his mother.

Anand's father, Sudesh, says he feels guilty for leaving the responsibility of taking care of Anand to his wife. 'As I used to be away most of the time, sailing, I did not know the difficulties she was going through in bringing him up. But it wasn't really tough for me to accept Anand. Having a special child is not the end of the world. All that you need to do is to find the best ways to make the life of your child better,' says Sudesh, now working as a dredging consultant.

Chaya's eighty-nine-year-old dad, S. K. Ramanna, says his daughter is very brave. 'She didn't shed any tear when I told her that Anand was diagnosed with Down's syndrome. She said she would give him everything he needs and raise him like a normal child,' says Ramanna, an electrical engineer retired from Indian Telephone Industries Limited. 'There are no failures in life. There isn't anything that you can't overcome with will and determination,' he adds.

'Maybe if Anand was a normal child, I would have had more tensions in life. We have given him everything, and we treat both our children equally,' says his mother.

Anand is quick to correct her. 'I am a normal kid, Mom,' he declares, replete with confidence that oozes out of independence.

'We accepted the fact that we have a special child and soon managed to see it no longer as a crisis or problem.'

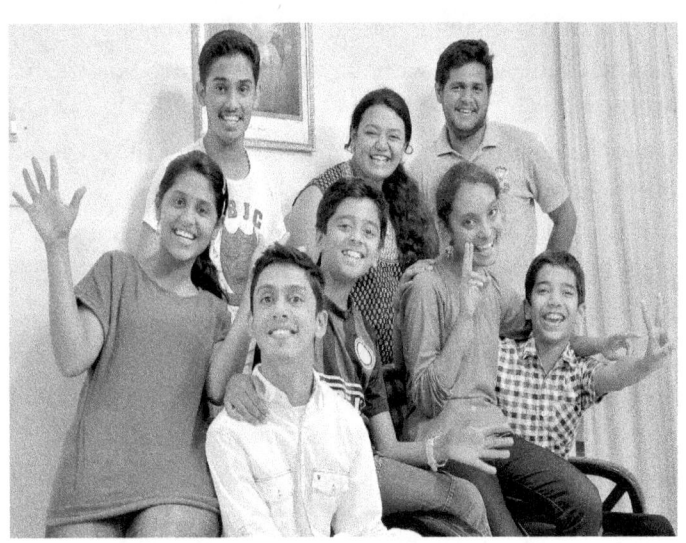

Million-Dollar Genius

Kedar S. Kulkarni. When destiny turned its back, he smiled. Fate helplessly became a doting guardian.

The first thing you will notice about twenty-year-old Kedar is his charming smile. Currently a bachelor of commerce student of D. G. Vaishnav College–Arumbakkam in Chennai, Kedar, was diagnosed with cerebral palsy (CP) when he was just thirteen months old.

His face lights up with a smile as his mother, Meenakshi Kulkarni, a special educator, begins to narrate the story of their journey together so far. He is eager to take over: 'I don't cut cakes, but I listen to music on my birthdays.' His speech is slurred, yet it's a treat to watch him communicate with his mother. The duo understands each other perfectly.

'I noticed that he had delayed milestones. He was floppy, could not sit without support, and couldn't carry his own weight. After he was diagnosed with CP, we put him on various therapies, which continued for fifteen years. He got admitted to a special school when he was two and a half years old. He started walking with support but would often fall on his back, hurting his head. Those were difficult times for his teachers and us,' his mother remembers.

To save Kedar from serious head injuries from his frequent falls, his parents designed a cap with an additional padding on the back. 'Since Chennai is very hot, we didn't want Kedar to suffer due to the cap. So we kept on improvising the design and finally zeroed in on a skating headgear, which is sufficiently airy and protective. Kedar used the same headgear till he was eleven years old,' says Meenakshi.

According to his mother, the boy wasn't serious about his studies until he was in the eighth standard. 'He wanted constant encouragement and help with studies. One fine day, when he was in tenth standard, Kedar told me that he no longer wanted me to help him with the studies. I was shocked, but he was adamant. But we respected his decision, and he scored 89 per cent in the exam.'

Kedar says he never liked any subject in particular, but zoology was 'sort of okay'. 'I liked zoology a little bit because there was no drawing and everything was theory.

I wanted to take up science, but the college authorities told me that I will have problems doing laboratory work without an assistant. It was sad, but I was ready. Instead, I took commerce and will pursue my CA.'

The boy's favourite pastime when he was eight was listening to World Space radio. While tuning the channels, he once listened to Hindustani classical music, and this was a life-changing moment for him. He began to take interest in music and soon became proficient in both Hindustani and Carnatic classical. Kedar even ran his own musical blog.

'He used to listen to the concerts in All India Radio every Saturday and Sunday and would upload them on his blog later. Now we take him to all concerts. Actually, we are a family which loves music. I am a trained Carnatic musician,' Meenakshi says.

Like many special children, Kedar is fond of gadgets. He started operating a laptop when he was in the third standard after his teacher felt that he could use it for communicating better. He makes notes on his laptop and files them at home after taking printouts. According to his mother, his teachers are immensely supportive. The University of Madras has accepted the family's plea to accept Kedar's printed answer scripts as a special case.

'We accepted the fact that we have a special child and soon managed to see it no longer as a crisis or problem. From my experience, I can say that we found the lesser-known institutions more

effective than the big names. He may have to depend on someone for the rest of his life, but we are trying to make him as independent as possible. I need to earn enough money to ensure his future,' Kedar's father, Shashidhar Malatesh Kulkarni, an engineer, says.

He recalls the difficulties they faced when trying to get Kedar admitted to some of the reputed schools in Chennai. 'Many of them refused to take him in. Those were difficult times for the family. Even after he got admitted to a school, Kedar used to come home and tell us about the difficulties he faced, and we had to shift him to another school,' he says.

A few not-so-pleasant experiences have been hardly capable of holding the patient and persevering Kedar from continuing his studies, and now he is in love with his college and friends. He even participates in rallies and all college functions.

Kedar is fluent in Kannada, Telugu, Tamil, and English. 'I always listen to music and want to start a music-archiving centre. I watched a Tamil movie, *Paradesi*, along with my grandmother and mother on the last day of my class-12 examination. When I was fourteen years old, I flew in a plane to Pune—my first flight. I was holding my mother's hand till I got down.'

For Meenakshi, bringing up Kedar was a very special experience. 'Things weren't easy for anyone of us, but we had Kedar to give us strength,' she says.

Kedar wanted his mother to name the college which refused to admit him. 'You have proved them wrong, and they lost a brilliant student like you,' says his mother, who has learnt to look at the brighter side of life.

Kedar gives an approving smile, a million-dollar one!

'Because we have faced the possibility of our child never walking, when we saw him walk, we were overjoyed. I still feel that what he is going through is unjust. But he has moved on, and so have we.'

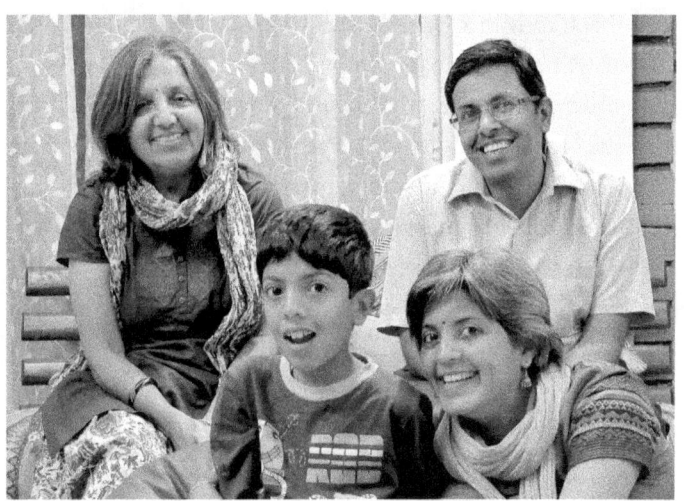

Classical Gem

Ananth Kavitha Ganesh. In the vibrations
of music he finds whispers of solace.

Life would have been different for thirteen-year-old Ananth had he been diagnosed correctly.

The boy was eight months old when his parents began to notice that his head would often drop all of a sudden. Ananth was referred to a paediatric neurologist, who diagnosed it as

a form of seizure. He was put on antiseizure medication, which helped reduce the dropped head syndrome, though not completely.

The family then decided to seek a second opinion and took him to a doctor in Mumbai, who diagnosed the problem as infantile spasm, a form of seizure. 'It was then we realised that he was wrongly diagnosed by his doctor. We went back to him when Ananth was four years old, and the doctor was quite embarrassed when we told him about it. I remember him telling the receptionist not to charge us,' says Kavitha Krishnamoorthy, Ananth's mother, a social worker.

'We don't blame him or are angry with him for what happened to our son, but we wanted him to know what happened to Ananth,' says Kavitha.

'His CT and MRI scans were normal. If his problem was diagnosed at the right time, things would have been different for him. We stayed in Mumbai for a month and started various therapies for him. The doctor told us that the academic performance of Ananth is likely to be poor, but he would be gifted with some other talents,' recalls his mother. According to her, some doctors have said that Ananth has autism, while others opine he has autism-like behaviour.

The Centre for Child Development and Disabilities was Ananth's next stop, and he underwent various therapies and special education there. At the age of three, he was admitted to a Montessori and stayed there for the next two years. His medication went on till he was seven years old, and the seizures stopped for two years. 'But it resurfaced, and he was back on medication again and continued it till October 2013,' says his mother.

Ananth has changed four schools in eight years. His father, Ganesh Anantharaman, an organisation-development consultant, says that he has never doubted the intentions of the schools. 'Our search for a school which would put less pressure on Ananth continued. This is something which most parents with a special child go through. It took us some time to realise that Ananth needs a specialised kind of school that would make him comfortable,' says Ganesh.

In 2006, the couple launched Kilikili, a trust to create inclusive public spaces for special children. 'We wanted to give special children a chance to play with other children. We worked in three public parks and used the corporation money to offer facilities for children with disabilities to play besides the existing recreational facilities for children,' Ganesh says.

From the age of three, Ananth showed inclination towards music. He began to even speak through songs, and most of his music was self-taught. Happy to see his love for music, his parents ensured that he got wide exposure to music.

'He likes classical music and is fond of melodious songs. He does not like fast beats. He loves all semi-classical songs on Lord Krishna and has even composed a few of them. Ananth has his own way of coding the songs as well,' says Ganesh.

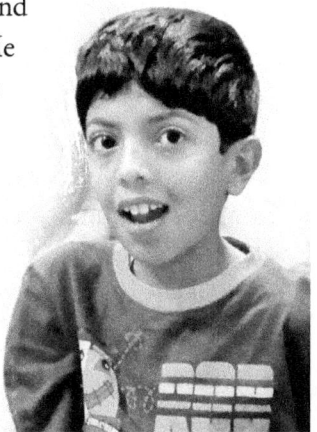

While listening to songs, Ananth often

surprises his parents with his remarkable observations. His attention to detail is sharp when it comes to music. 'Music is everything to him. It is part of his identity. But he does not sing to impress anyone. He prefers to sing for himself and loves to be in a world of music all by himself.' His father, a trained musician, understands his son perfectly well.

Ananth assumes the role of a critic when his father sings and that of a teacher if he happens to sing out of tune. 'He catches it immediately. He smiles at me and makes me sing again. Music relaxes him, and he enjoys it more than anything else. He does not seem to enjoy his studies much. We are now clear as to what he wants,' his father says.

Ananth's parents have not set any long-term goals for their son; they are happy with the way he is. The future, too, does not seem to bother them much, and they hope the advancements in technology will help take Ananth's music to a wider audience.

In January 2013, the couple launched yet another project under Kilikili, Sampoorna Music Therapy Centre, with the aim of using music and musical instruments to help children with autism.

'Dealing with more special children at the centre helped me understand my son better and grow closer to him. It is important to work on the strengths of special children instead of trying to correct them,' says Ganesh. He is hoping to form a community in the future where families with special children can stay together.

Popular vocalist and Ananth's aunt Bombay Jayashri noticed the boy's musical inclinations and conducted a workshop along with her team for children with autism.

Sixty-six-year-old Padma Krishnamoorthy, a retired teacher and Ananth's grandmother, says Ananth is a flawless child. 'I love his company. He wants me to cook for him and sleep near him. He loves *roti* and *dal*. He teaches me to sing and does not spare me if I do not do it well.'

Kavitha considers Ananth a blessing as he has brought much music and happiness in her life.

'Of course, I had my moments of ups and downs. The happiness of a parent when the child utters the first word and takes the first step is beyond what words can describe. For us, this happiness was more special. Because we have faced the possibility of our child never walking, when we saw him walk, we were overjoyed. I still feel that what he is going through is unjust. But he has moved on, and so have we.'

Ananth has fallen asleep even as our conversation is on. And as he smiles in his sleep, we can feel that in his own kingdom, soothing whispers are heard often.

'His life inspires me. Sometimes I ask God to make me paralysed and give my strength to him.'

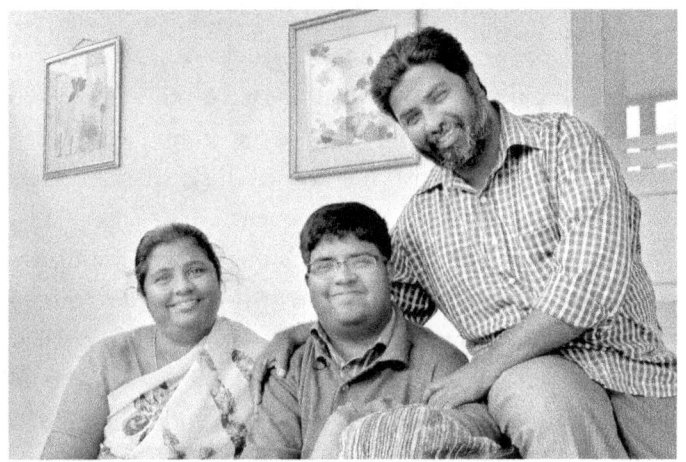

Hope Chaser

Joseph Dizon. At times he loves chasing the cricket ball, but most often, he chases his dreams.

When Joseph Dizon was eight years old, his mother would wrap a sari around his waist and tie it to a pole. Crude as though it might seem, this method helped the boy gain the right balance to wield the willow every evening. Joseph was passionately in love with cricket. He would bat for hours together.

Born on 16 November 1993, Joseph was a smart kid. He began schooling at the Sacred Heart Boys School when

he was six. During the summer holidays in 2000, Joseph accompanied his parents to Tiruchirappalli (Trichy). After the train journey, Joseph complained of headache.

'He was crying. He said his right ear was hurting. He started vomiting, and this continued for a week, and we took him to a doctor. After a week, his headache resurfaced, and he slipped into a coma. At the emergency ward, we were told that he was paralysed. We did all the tests, and we were told that he had some kind of worms in the brain. He was then referred to a neurologist,' remembers his father, Aruldass Xavier, who is a helper at an apartment.

From Tiruchirappalli, he was brought in an ambulance to St John's Hospital in Bangalore, where he was admitted for nearly two months. The family, with the help of their friends and relatives, pooled in all the money they could for his treatment. The doctors extracted fluid samples from around his spinal cord and sent them for further testing. (This process is called lumbar puncture or, spinal tap, used to ascertain problems that involve the brain or spinal cord.)

Further diagnosis revealed that Joseph had brain herpes. The doctors told the family that his brain cells were damaged, affecting the nerves. The left side of the boy's body had been paralysed since then, and his speech too had been partially affected. He was finally diagnosed as a cerebral palsy (CP) child.

'After I recovered a bit, my mother would carry me to a park so that I could play cricket. I love batting. Matthew Hayden and Adam Gilchrist are my heroes. All my friends used to support me and help me bat. My mother used to constantly watch me and would come to the field often to check if the sari knots were intact. After I am done with

batting, my friends would carry me to the other end and would make me sit on a chair and bowl,' Joseph reminisces.

'My mother would hug and kiss me every time I took a wicket. I even had a hat-trick and scored a century when I was twelve. That day is still vivid in my memory.' Joseph can never get tired of recalling his cricketing feats.

After the game, the mother–father–son team would head home, carrying the 'bowler's chair'. There was a fourth member in the family who used to follow Joseph to the ground. She was a white Pomeranian dog.

'Uegene was like my shadow. She would wait for me to come from school, and once, she even jumped into my school van. She loved ice creams. I think Uegene knew I wasn't well. She loved my batting, I think,' he recalls.

Joseph is a great fan of Indian cricketer Rahul Dravid, hailed as the Wall. 'I want to meet him one day and ask about the secret behind his success,' he says.

Joseph scored 70 per cent in SSLC exams and 65 per cent in PUC. He had a few struggles at Christ University initially.

'College was a whole different world for me, and I wouldn't come out of the class much. I had no clue how a college looked like. I was not sure if I will be able to adjust to the environment. I even stopped going to college for a month. But my well-wishers came to my rescue again. They told me that they believed in me, and I was soon back to the college.'

Joseph wants to take up a job after his studies to support his parents.

Joseph, fondly called Dezu, is a BA student of Christ University. 'When he was a small kid, he would often fight with his cousins. So his grandfather named him after Mike Tyson. Soon, the word Tyson became Dizon and, finally, Dezu,' explains his father.

Earlier, Xavier would drop Joseph to the college every day, where he used a wheel chair to move around. Things hadn't been all that easy for the family. Two accidents, one in 2005 and another in 2010, had weakened Xavier, and a surgery left him incapable of doing hard labour.

Joseph's mother, Arogya Mala, was a housemaid for some time but was unable to continue working due to constant migraine attacks. The family first lived in a slum. Later, they were lucky to have a small house allotted to them under a government scheme.

'His life inspires me. After completing his BA, he wants to do some computer studies. He is good at it. I want my son to study as much as he wants. I was in much pain after Dezu's one side got paralysed. Later, I happened to see another boy who was totally paralysed, but he was always cheerful. Then I realised how lucky I was. Sometimes I ask God to make me paralysed and give my strength to Joseph,' says Mala.

But Joseph seems to have told God, 'I am good as you made. In fact, I am better.'

'It has been a tough journey for me.
But I have not given up.
He is my energy. My hope.'

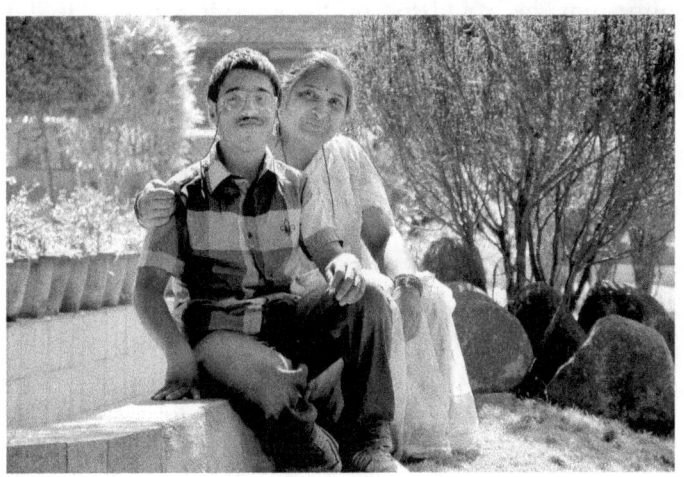

Dream Drummer

Vaibhav Kutnikar. In the distinct pitch
of the tabla he found his calling.

Vaibhav was a frail, hyperactive, short-tempered naughty kid. For Latha Garje, who was divorced even before Vaibhav was born, bringing him up wasn't a cakewalk. But she was a fighter, and Vaibhav is now a smart, semi-independent nineteen-year-old man.

'Vaibhav was born with mental illness, and his growth chart started showing retardation in the early days itself.

His neck straightened only in the seventh month. He had severe infections and used to vomit continuously. He also had a liver malfunction. I was scared even to feed him,' says Latha, a homemaker, recalling her ordeal in the initial days.

'I could not discipline him. He was enrolled in the pre-primary in the regular stream. When I tried to make him study, he would spit on me and scratch me. He did not have any sensory integration. I knew the importance of early intervention and did everything possible to help him. Thankfully, I had the support of my mother. To tackle his physical and psychological conditions, I took the help of yoga and pranayama,' she says.

Vaibhav was very attached to Latha's mother, Shantha Bai, a cancer patient who passed away six years ago. 'Vaibhav knew that she was very sick and that one day she would die,' recalls Latha.

To increase Vaibhav's lung capacity and to boost his appetite, Latha started taking him jogging. The mother–son team would regularly hit the park for their exercise routine. They also joined a laughter club. 'The laughter club helped him to differentiate between the right and left sides of the body. He did this by observing other members of the club,' his mother says.

Vaibhav was a student of Sri Saraswathi Vidya Mandir School for ten years.

'I am indebted to this school for integrating Vaibhav into the mainstream. Until he was in class 6, he used to attend classes sitting on my lap. I had a tough time making him write neatly on the four-lined book. Though his phonetic skills improved, his comprehension was poor. Teaching him mathematics was an incredibly tough task. But now his

handwriting has improved a lot, his spelling is good, and he can take notes which are being dictated.'

When Vaibhav was in class 7, his classmates started alienating him, getting his mother worried. 'I was upset but not beaten. I decided to teach him some life skills. Tabla classes, swimming camps during summer, bicycle-riding sessions, and many more followed. He is afraid of swimming alone. He performs *dainik havan* [a religious ceremony] at the Arya Samaj temple every morning with me. He chants the mantras while in a group.'

In a bid to make him more independent, Latha decided to make him take the bus to the school and to his tabla classes. She used to take the help of conductors and would follow Vaibhav without him knowing about it. Today, using a bus pass, Vaibhav commutes all by himself.

He began to attend skating classes to improve walking, which helped him gain speed.

'We used to attend music and dance concerts at the Indian Institute of World Culture. I noticed that Vaibhav was more interested in the percussion artiste than the main performers or anything else on the stage. He also whistled well, which meant he had the rhythm sense,' she says.

At Bhartiya Vidya Bhavan, Vaibhav learns tabla under Vidwan Srikanth Devipur, and he has already passed his first- and second-year exams. Since 2008, Vaibhav has bagged the first prize in the

annual instrumental solo music competition Kalaangana, organised by Information Resource Centre.

At the Bharath Special Olympics 2008 in Hyderabad, he has participated in cycling with his mother playing the coach-cum-mentor. He has even joined the Bharath Scouts as a cub and has been performing for the national festivals since 2009.

Vaibhav enrolled for the National Institute for Open Schooling in 2011–2012 for the class-9 exams and later attended the contact classes.

'He needs to clear one more subject now. He likes travelling, so I used it as an incentive to make him do well in studies. We have travelled to Kedarnath, Badrinath, Kashi, Nasik, Gokarna, Shirdi, Nainital, Mangalore, Delhi, and Agra,' she says. And she adds, 'So far we have been travelling by train. Vaibhav told me he wants to travel by air at least once. I told him we would.'

Vaibhav is currently undergoing free computer-training classes and comes home and practises on a system donated by the Rotary movement. He helps his mother shopping, cooking, getting photocopies, buying milk, and even taking care of her when she falls sick.

'I want to play tabla on TV one day. I like the rubber-stamping job at the post office,' the boy says about his plans for the future.

He says his mother is his best friend.

Latha says Vaibhav speaks to his father over the phone every day. 'He used to come home for Diwali and for Vaibhav's birthday every year. It has been a tough journey for me. But I have not given up. I believe in God. Vaibhav is my energy. My hope,' says the mother.

As he spreads a new music in the air with his tabla, for his mother, hope too is in the air.

*'I have discovered many things in my daughter.
She was a bubbly, cute girl, then I found
a singer in her, and now I see a great writer.
She is my precious child.'*

Rewriting Destiny

Shubashree Sarkar. When all hope
fell, she scripted an epic rise.

Born in Dubai, Shubashree spent the first ten days of her life in the ICU, owing to pneumonia. She regained her health soon. Her parents fondly called her Stuti.

Music was very much a part of this Bengali family hailing from Ranchi. Little Stuti's favourite song was "Yeh

Raat Bheegi Bheegi" from the Hindi film *Chori Chori*. Her father, Sandip Sarkar, used to often sing Indian playback singer Lata Mangeshkar's songs to make her sleep. She would often throw tantrums so that her mother, Joyshree Sarkar, would sing to her another Lata song, "Naina Barse Rim Jhim" from the movie *Woh Kaun Thi*.

When Stuti was around two years old, her great-grandmother passed away. When the rituals were under way and the priests were chanting the *mantras* (a sacred utterance of words believed to have psychological and spiritual power in Sanskrit), Stuti surprised everyone by reciting the Sanskrit mantras without a break.

'We couldn't believe it, and even now we have no idea how she did it. She had never heard these mantras before. When she was one and a half years old, Stuti started singing songs all by herself, and most of it were perfect. I still remember she could easily sing over 100 songs by listening to the small tape recorder we had,' says Joyshree, a postgraduate in psychology.

During the same period, her parents noticed some behavioural changes in Stuti. When she turned three, she had an epileptic attack one night, and immediately thereafter, she lost her speech.

Stuti is twenty-two years old now, and she has never spoken a word ever since. 'We consulted a doctor in Dubai in 1994, and it was confirmed that she had autism. We took a second opinion and got her to Hinduja Hospital in Mumbai. We were really hoping that she would recover. The fact that Stuti may never be able to speak again and we would never be able to hear her sing again was tough to accept.'

Joyshree began teaching Stuti English alphabets at the age of five, and it almost took her a year to successfully complete the task. Her husband, a sound engineer, is working in Dubai, and she currently lives with her sister, Amrita Sarkar, a lawyer.

Stuti had fallen in love with Dubai; its parks, the roads, and the beaches fascinated her. Whenever the girl had one of her severe epileptic fits, her father would take her for long drives.

'Those were really long drives. We would drive around till she fell asleep in the car. Stuti also loved swimming, and she came up with her own techniques to stay afloat in the water. Along with her father, she would spend hours at the Jumeirah Beach, swimming, but we had to stop regular swimming after she had an epileptic attack in the water,' says Joyshree.

When she was attending a special school in Dubai, Stuti began expressing her thoughts with the help of a communication board based on QWERTY. 'Whenever Stuti would get hyperactive, we would show her the board, and she would point her fingers at each letter and form words to communicate to us. In 1998, we bought her a portable typewriter, and she loved it. She always wanted a medium to communicate, and in two years, she graduated to computers,' says Amrita.

According to her, she has been writing small poems, notes, and even

articles for the past five years. 'She updates her Facebook account frequently—of course, with some help from her mother. She reads newspapers, watches TV, and her GK is good,' says Amrita.

Amrita feels that Stuti's thoughts are profound, but a little patience is needed to capture them. 'Her ways of expressions are inspiring and remarkable. There is restlessness right now, but her writing is outstanding,' says Amrita. Stuti is often lost in her thoughts, and she loves to be on her rocking chair. 'She wants to be a writer and also wishes to pen her autobiography some day. She is definitely a person gifted with creativity,' she adds.

Stuti's cousin Nayanika Sarkar, a UKG student of SSB International School, is very fond of her. 'I play Ludo with Didi [Stuti]. I also play the ball-catching game. Didi gave me a magic slate on my birthday,' Nayanika tells us.

For Joyshree, bringing up Stuti was an experience she enjoyed. 'My advice to mothers with special children is that you should always respect their feelings. Do not ever lose patience, but try to understand their problems and what they are trying to communicate to you. I have discovered many things in my daughter. She was a bubbly, cute girl, then I found a singer in her, and now I see a great writer. She is my precious child.'

At this point in time, Stuti, who is battling severe cough and cold, starts pointing at the communication board, with her fingers soon running from one letter to another. Finally, her message reads, 'Thank you for your visit. Please ignore my behaviour. I am really happy to see you. Your title, *Precious Souls*, is fantastic.'

When I tell her that she will become a great writer one day, Stuti grabs the board again, and her message reads, 'Thank you. God will give you the reward for blessing me.'

Her expressions are abundant with hope and confidence that God, who has scripted her destiny, has reserved enough strength in her to rewrite it.

'I could understand what my wife was going through as a mother when we were told that our son is unwell. It was important that both of us do not fall into a state of depression, so I stayed on with a positive frame of mind.'

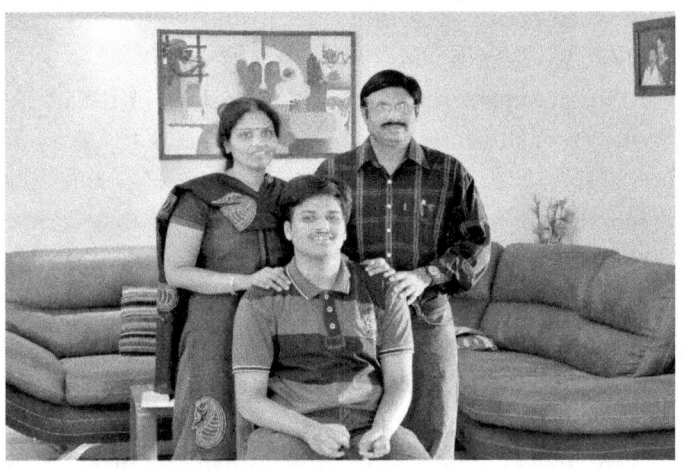

Summing Shades

T. G. Samarth. In complex calculations of
life, he paints a picture of triumph.

'It's Samarth with *th*, okay?' He wants us to get his name right. The eighteen-year-old boy, clad in a blue T-shirt and jeans, is a picture of composure when his parents begin to share his story. He takes the seat next to his mother and spreads his paintings around for us to see. 'I am Chotu,' he tells us.

Samarth was a healthy child until he was eighteen months old. Then the family began noticing the child occasionally shaking his head continuously for brief periods.

'I am from a village, and Samarth used to enjoy the bullock cart rides. I think he loved the vibration he used to get when travelling on bullock carts, tractors, and lorries. He had a craze for toys and would keep them next to him even when he was fast asleep,' recalls his mother, Sarvani Ganesh, who works with IBM.

During one of their storytelling sessions in the night, Sarvani wanted Samarth to look at the moon. 'It was a full moon, and I tried my best to get his attention. He was unable to spot the moon or any other distant objects. When he turned two, we admitted him to Akshara Montessori, although his fine motor skills weren't good. The principal was very astute, and she advised us to take some medical help,' says Sarvani.

Later, she was invited to the school to observe the boy, and after a week, she realised that her son had some issues. At a children's hospital, Samarth was finally diagnosed with moderate autism.

'Initially, we both were in denial, and this continued for a long time. We thought he could be cured within six months. We went around many hospitals for a year, seeking opinion. At the same time, I had this feeling of anger. I used to constantly ask, "Why me?"' Sarvani recollects.

So much so that she even thought it was some sort of a punishment. 'During my assignments abroad, I took his medical reports to doctors in Japan, UK, US, and many other countries. Honestly, these trips changed my perception as I saw parents dealing with kids with more-serious issues. I realised I was overreacting,' she says.

Her husband, T. M. Ganesh, a chartered engineer, was able to accept the situation with much more equanimity.

'I consider two things most important in my life. One was passing engineering, and the second is my son. Chotu was a very cute boy when he was born, and hundreds of people had come to see him at the hospital. I could understand what my wife was going through as a mother when we were told that our son is unwell. It was important that both of us do not fall into a state of depression, so I stayed on with a positive frame of mind,' says a soft-spoken Ganesh.

It was after Samarth's fifth birthday that his parents began noticing some 'surprising skills' in their son.

'I had taught him English alphabets for a year, and one day, he wrote on a piece of paper that he is studying for MBBS with specialisation in psychiatry. When he was seven, he started solving mathematical problems in algebra, differentiation, and integration—all really complex ones even for a high school student. I realised that Chotu is gifted with some unique talents,' says his mother.

Ganesh shows us Samarth's notebooks filled with his thoughts and mathematical equations. 'We have preserved every bit of his writings. We have been surprised by his command over English and his ability to write thoughtful pieces right from his childhood,' Ganesh says.

He is not just a mathematical genius; he is

also a magician when given a brush and canvas. A watercolour painting with black and dark-red shades was his maiden attempt. Samarth has a note behind the painting, which reads, 'Every day, darkness is cleared with the bright sun, rising in the sky. Similarly, there has to be a bright day in everybody's life. So people always do not lose hope.'

It takes just five minutes for Samarth to make a painting, which, according to his parents, is the height of his patience. The boy has painted over 100 different themes, most of them related to nature. He also writes a brief note about each of his paintings.

Asha Kiran Special Needs School helped Samarth to further develop his painting skills, with the principal of the school going the extra mile to take the initiative to publish a collection of his work, titled *Rise Like a Sun*. Selected works of Samarth are uploaded on http://www.huesnshades.com/samarth.html.

Every morning, Samarth has an interesting routine. He, along with his father, cuts and pastes newspaper photographs on a notebook, and Samarth writes his own interpretations of the photos.

His mother has also taught him *Soundarya Lahari* (which means 'waves of beauty', a popular literary work in Sanskrit), which he sings for over thirty minutes without a break.

'He used to be a little hyperactive, and so we diverted his attention towards learning *slokas* [a couplet of Sanskrit verse, especially one in which each line contains sixteen syllables] to improve his concentration. This was a tough time, and we never used to go out much, thinking that his behaviour

would disturb others. He loves songs but would run out of theatres when the song sequences get over,' says Ganesh.

Samarth says he loves cricket, and for him, every player who comes on TV goes by the name Sachin Tendulkar. He practices yoga as well.

Samarth helps his mother in all household work, including cutting vegetables and cleaning utensils. He is also being trained to be more independent. 'Chotu taught me patience. He also taught me to see the hidden talents of others and accept people as they are. I learned what true love is from him. I am his student first and then his mother,' says Sarvani.

As Chotu engages in complexity and creativity, he looks ahead with optimism to tackle any challenge with his acumen in math and arts.

'God has given me a special gift, and I have accepted it. Having him in our life has been an experience we never want to trade for anything.'

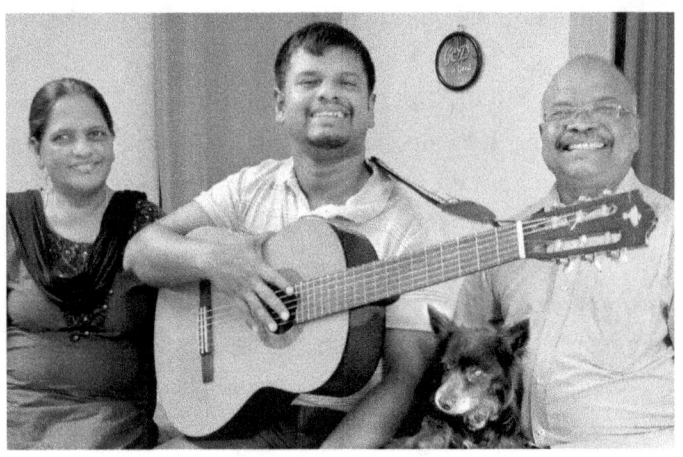

Mellifluous Strings

Samuel Ashish Marcus. When confidence
was wounded, he healed it with music.

Samuel (Sammy) is waiting at the gate to welcome us, along with his mother, Annamma Marcus. With a warm smile, he escorts us to their first-floor flat. His father, Marcus Chacko, is recovering from an accident and moves around with the support of a walker. His sister, Tobey Ann, an MS student, is ready to catch a train.

Sammy sits next to his mother. Nikki, the fifth member of the family, a seventeen-year-old Pom, joins us as we begin our conversation.

'We were in Lucknow when Sammy was born. He was a premature baby, and my daughter was just two. Soon after his birth, he had high fever, and the nurse even refused to show the thermometer to me. But he recovered and was a happy chubby child. He never crawled but began to run very fast at the age of one. We did not know he was a child with mild autism,' says his mother, a social worker.

As Sammy grew up, he began showing keen interest in music. He started operating the tape recorder when he was just one year old. He would sit alone, for hours together, listening to music and playing with blocks. 'He never mixed with anyone and loved being left alone. I used to wonder why he was so silent,' says his mother.

He often ran out of his house, which became a serious issue, and the family had to always keep the door shut. 'Once, we had guests at home, and our attention got diverted a little from him. Sammy was picked up from the middle of a busy road by our alert neighbours,' Annamma recalls the difficult times they had.

His parents took him to a psychiatric centre in Lucknow in Uttar Pradesh. 'The lady at the centre assessed Sammy, conducted an IQ test, and finally declared that the boy was perfectly normal. But I still had my doubts. She asked us to bring Sammy for another check-up when he turns seven. But she also asked me to go through some counselling,' Annamma tells us.

In 1991, Sammy was admitted to an LKG school, and the parents continued to believe that he was fine. Nonetheless,

the school wasn't a pleasant experience for the boy. 'It was a harrowing time for Sammy. People were calling him names. Every time the teacher screamed at him for not responding to her, he would be scared. Finally, we decided to change the school, and he was happy,' his mother says, fondly hugging her son.

After a while, the family moved to Pune and confided about the boy to one of their friends in Australia, who asked them to consult Dr M. C. Mathew, a Chennai-based developmental paediatrician who ran a centre called Aashirwad.

'He never brands any child with a specific problem. He told us about Sammy's special need in terms of games, habits, and even socialising skills. We were asked to touch the boy and look into his eyes and talk, always. We were also told to communicate with Sammy in one language [English], considering our frequent transfers to different states. When he turned seven, we admitted him to a Catholic school in Pune, and he studied there for four years,' says Annamma.

Sammy joins the discussion. 'I had a red cycle. I used to race with my best friend Alex Washington, and I used to win every time. I loved the Bible Seminary and the Kids' Club. I loved the hills. There were many families living on top of the hills. We used to cycle really fast from the hills.

Again, I used to win.' The pace of his speech is slow, but he is loud and articulate.

Annama says an article in the *Reader's Digest* published in 1992 changed her life. The story of a girl, Georgiana Thomas from the US, featured under the title 'Dancing in the Rain', gave her a new perspective in dealing with Sammy.

'I began to understand him better, and for the first time, I came across the word autism. I went back to Chennai, and the doctor confirmed that Sammy's case was very similar to Georgiana's. The doctor in Lucknow failed to diagnose my boy, but the Chennai doctor, whom Sammy calls uncle, saved him.'

In 1997, the family moved to Hyderabad, and Sammy found it difficult to adjust to the new environment. The boy was homeschooled for six months until the mother got a piece of advice from the son. 'One day he asked me to stop my teaching and reminded me that I was his mother and not teacher. We admitted him to Gitanjali Devshala in Secunderabad.'

Sammy says he loved the Bollywood movie *Taare Zameen Par*, especially the character of Darsheel Safary. 'I also like Aamir Khan, he says as he gets ready with his guitar to sing to us "Main Kabhi Batlata Nahi" from the film. His four-legged friend Nikki comes around and acknowledges him. Nikki was brought home after the doctor suggested to the family to adopt a pet to give the boy company.

'Sammy grabbed the guitar, which was taller than him, when he was just one year old. Within a year, he tried his hands at piano as well,' says his father, Marcus.

Sammy now holds a bachelor's degree in Western music (vocal and piano) and a Trinity eighth-grade in piano. He has composed ten songs so far and also teaches piano to other students. He works as an assistant librarian from Mondays to Fridays, and on Saturdays, he teaches a children's choir.

'Music is a gift that I received from God. My favourite music composer is A. R. Rahman. Do you know that he won an Oscar? It is his style of music that attracts me,' says Sammy, a recipient of the eleventh CavinKare Ability Awards 2013, instituted by Ability Foundation.

Marcus says that the family is open to all kinds of suggestions from friends and professionals on helping Sammy. 'Our journey so far was challenging, but it was also a learning experience. Sammy has many needs, and over the time, we have understood a lot of them. Of course, it has taken a lot of patience,' Marcus, who works as director and personnel at Operation Mobilisation India, tells us.

'God has given me a special gift in the form of Sammy, and I have accepted it. Having him in our life has been an experience we never want to trade for anything,' says his mother.

Sammy is set to give us another one of his performances, "I Dance to a Different Tune", composed by Dr Parasuram Ramamoorthi, for which he gave the music:

I dance to a different tune,
Don't look at me like that,
I may not follow you,
May not be speaking like you.

Listen if you can,
Accept me as I am,
Even though I speak,
A different language.

Nikki is restless, and it is time for Sammy to take his pet for a walk, but not before she joins us for the photo session.

'Wherever I go, Nikki follows me,' Sammy explains with a childlike smile as he takes another stroll with contentment.

*'There is nothing more precious to me than my son.
He does not consider his physical condition as a limiting factor.
He enjoys life to the fullest and deals with
every situation with a smile.'*

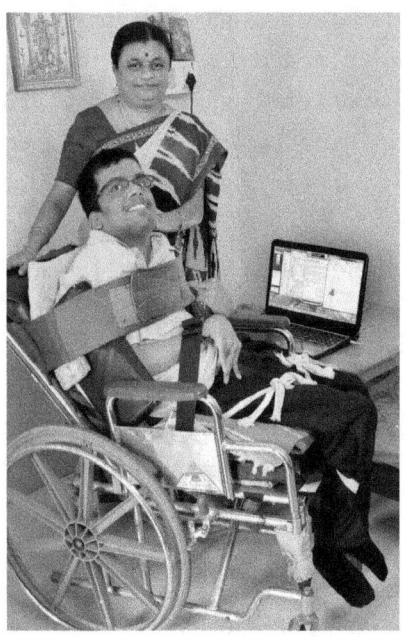

Unchaining Ambition

Avinash Sonnad. Understanding his
abilities, he trounced his weaknesses.

'There are times I want to fly. Such thoughts come when I am alone. But I know I will never be able to fly or even walk.

I have accepted my condition.' It is the tinge of courage and not disappointment that resonates in the words of twenty-six-year-old Avinash, or Avi, neatly strapped on to an improvised wheelchair.

Avi's father, Siddanna Sonnad, is an employee of the National Sample Survey office. His younger brother, Sanjeev, is an engineering student. 'My father named him Sanjeev after the mythological medicinal plant *Sanjeevani* so that he may help me get back to life. The doctors told my parents that I should have a brother or sister to take care of me.' Avi has cerebral palsy (CP) with spastic quadriplegia (affecting all four limbs and making them completely inactive).

Avi was a premature baby, but the doctors at the government hospital in his village declared him a healthy baby.

'Since he was crying and drinking milk, the doctors felt that he was healthy, but six months later, we noticed that he couldn't hold his neck straight. We first consulted a doctor who used to visit our village hospital once every six months. Later, he referred us to Dr M. S. Mahadevaiah, and we were really moved by the care he showed. He was very understanding. He knew the state of mind we were in,' says Vidya, his mother, a housewife.

'I was sad when I came to know about Avi's condition, but it changed after his initial schooling, which gave me the much-required courage. In our village, Avi's was the first case of CP, and we had to suffer a lot of humiliation.' Vidya recalls some of the painful experiences.

The comments and remarks made by some of her relatives were upsetting. 'There were even people telling us Avi's condition was due to the sins we committed in

our previous birth. They had little idea about the health condition of our boy,' Vidya recollects.

According to his father, today, whatever Avi has achieved is because of constant training and support he has received. 'It made him independent to the extent that today, he is confident of sitting on the wheelchair, all strapped,' he says.

Avi uses an improvised wheelchair so that he doesn't fall out. In addition to his entire body being strapped to it, he has been provided a padding support. He says he can sit on the wheelchair for six to seven hours at a stretch.

Avi's best friend is his laptop, and he often operates it lying down. He doesn't use the keypad; instead, he uses the system through oral commands. The inbuilt speech-recognition software (speech-to-text) does the job for him.

His proficiency with the laptop is amazing, and he does not conceal his disappointment when the software fails to recognise some of his commands. 'It's 90 per cent perfect. I am very active on Facebook,' he says. Avi uses the same speech-to-text tool to send an SMS by activating the phone's Bluetooth device and later synchronising it with his laptop.

A graduate in computer science (BCA) from Christ University, currently, Avi is involved with a project along with his San Francisco–based friend Senthilkumaran. The duo is developing a website that will make computer science easy for everyone.

'I am keen to take up some work, but it has to be home-based since I cannot commute,' says Avi.

While studying in college, Avi used to commute by Volvo buses as they were wheelchair-friendly, and his mother would later reach the college with his lunch. With Avi needing support to use the toilet, there were occasions when he alerted his mother to be in college early so that he could use the washroom.

Avi's father, Siddanna, has dedicated his entire life for his son. 'There is nothing more precious to me than my son. He does not consider his physical condition as a limiting factor. He enjoys life to the fullest and deals with every situation with a smile. We have provided him everything that we could afford. I wish I could provide him some more luxury.'

Avi says his mother and father are 100 per cent dedicated to him. 'I mean it. It is 100 per cent. I can feel it. My father says I am always a baby. He loves me more than himself. Almost every day, I fight with my mother. You know *kutti, kutti* [petty] fights.'

A voracious reader, Avi says all his birthday presents come in the form of books. He says he has read all the bestsellers of Dr A. P. J. Abdul Kalam. 'I email Dr Kalam on his birthday every year, and once, I received a reply from him. I once shook hands with him when he came to our school,' he says.

While he has nuggets of dreams to be fulfilled, he teaches an important lesson: in adversity, too, there is ample scope for ambition to flourish.

*'I am alive today because of my daughter.
She is a blessed child in our family, and
I am thankful to God for her.'*

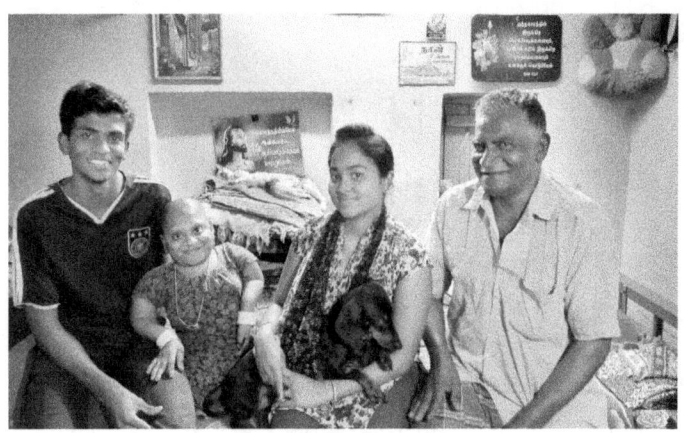

Little Treasure

K. Sheeba. She may be small, but her resolve is gigantic.

Rajapandian Koil Pichai is carrying Sheeba in his arms and is waiting for us at the front door of his two-room house. The door opens to the road, and parked outside the house is a pushcart, the only means of livelihood of the family. Pichai is a vegetable vendor.

He lost his wife, Abela, to liver cancer in 2008. Twenty-eight-year-old Sheeba is his eldest daughter. She was diagnosed with rickets, a disease caused by vitamin D deficiency that makes the bones weak, when she was two.

Sheeba is just two feet tall and is extremely shy. Frequent wheezing has slowed down her speech, and at times, she struggles for breath. She bursts into laughter when she hears her father tell us that she is the 'lucky girl' in the family. She laughs like a child.

'It was a normal delivery, and she was perfectly okay for a year. She had lots of hair then, and she was a very playful kid. The problems began after she began making attempts to walk,' Pichai recalls. He had lost his first child, Pooja, when she was three.

Sheeba's parents tried to help her walk, but she was unable to have control over her limbs. They took the girl to Kovai Medical Centre and Hospital in Coimbatore.

'The doctor told us that she is suffering from dwarfism and rickets. Later, with the help of a friend, we took her to a military hospital, and the doctor there told us that our girl would not survive more than seven years. We believed him. I married my *murappennu* [uncle's daughter], and many felt that this could have caused Sheeba's condition. I don't know.'

Sheeba outlived her doctor's predictions and went on to celebrate her tenth birthday, and her parents were happy. They admitted her to a special school, where the painter in her was born. 'I was influenced by one of my teachers, Lathika, who taught me warli painting. Ideas keep pouring in if I start painting,' says Sheeba. When asked about her favourite painting, Sheeba takes a moment to think. 'I love all my paintings.'

She usually completes a painting within an hour, but it takes her a whole day to finish a landscape. 'I paint every day, and I use fabric colour. I do not step out of the class. I like to be quiet and enjoy seeing people,' says Sheeba. A

Precious Souls

hardcore fan of Tamil actor Vijay, Sheeba wishes to meet him one day. 'I don't know why I want to meet him, but I have a lot to tell him if I get a chance to meet him one day.' She is happy that her paintings are being sold.

Sheeba's younger sister Jeba Vini is doing her bachelor of commerce, while her brother Jeba Wilson has flunked all subjects in his tenth exams. Sheeba knows why her brother hasn't done well in the exams. 'He played football even during the exam period!'

Sheeba calls the shots at her house and keeps a close watch on her siblings. Wilson, who plays as a full back for a local football club in the area, says he is scared of his sister. 'There's no escape from her. She is still angry with me for failing the tenth class.'

'My sister wants us to do everything she says. We will have to report to her the moment we are summoned. She is strict, but without her, this house is dull,' says Vini.

Pichai says it's a miracle that he is managing to run the family with the meagre earnings from selling vegetables. 'It was tough for me after I lost my wife. I am alive today because of Sheeba. God is testing me in many ways. Sheeba is a blessed child in our family, and I am thankful to God for her,' he adds.

He hopes to buy a new pushcart soon and, some day, buy an automatic

wheelchair for Sheeba. Sheeba is getting restless and starts wheezing. Her pets Rat, a cat, and Princy, a kitten, have dozed off, while Jessy, the dog, is alert. When asked about what she wants from life, Sheeba says, 'I have no dreams. But my wish is to live so that I can paint every day.'

She may not have any dream, but with the little happiness that she spreads in her home, dreams do yearn to come to her. And it shows in her paintings.

*'I am really lucky to have a son like him.
He is the king of this home.'*

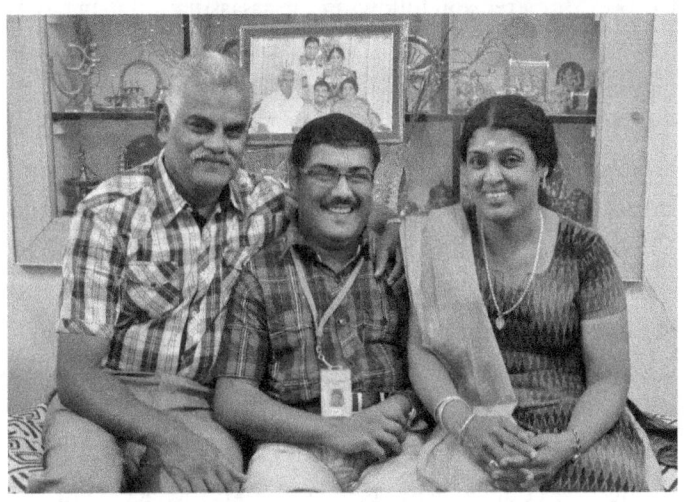

Living Absolute

Sumesh Menon. He has mastered the
art of living by shaking hands with distress.

Sumesh was born on 7 November 1984, exactly seven days after former Indian prime minister Indira Gandhi was assassinated. Kerala, a state infamous for frequent strikes, was mourning the death of the national leader. A curfew was in place as there were rumours of possible violence.

In Thenari Village, a historic place near Elappully, eighteen kilometres from Palakkad in Kerala, a family was

hoping against hope to get access to a vehicle to shift Vijaya Menon to hospital.

'My husband was in the Indian Air Force and posted in Delhi. He had applied for leave so that he could be with me during the delivery, but it was not sanctioned, owing to the prevailing tension following the assassination. My father had a tough time in finding a vehicle. We knew reaching my regular hospital would be difficult,' Vijaya recounts.

Around three in the morning, Vijaya's father managed to arrange a car, but she couldn't reach her family doctor because of the road blockades. Unable to bear the pain, Vijaya got admitted to a nearby government hospital. 'The staff at the hospital were unsympathetic. When we pleaded with them to get a doctor, they refused to do so, saying it was an odd time. Finally, the doctor came. It was a forceps delivery with some complications,' says Vijaya.

The family believes that Sumesh is a victim of doctor's negligence coupled with Kerala's strike menace. 'Further investigation revealed that the blood circulation to Sumesh's brain stopped for a fraction of a second. This resulted in him becoming a child with some inborn defects. It was a chaotic scene at the hospital, with no proper medical aide or staff. It was really tough for me,' she says.

Sumesh was in coma for over a week, and his body had turned completely blue. He lost his hair as well. 'We shifted him to another hospital. I was not able to breastfeed him either. He also had frequent fits. Later, we shifted him to the military hospital in Jalandhar.'

When Sumesh was two and a half years old, the family went to NIMHANS. The mother–son duo stayed at a rented place nearby the hospital so that Sumesh's therapy sessions

could go on as planned. Sumesh's father, Shivshankara Menon, joined the family too after getting a transfer.

'When Sumesh turned three, the doctors confirmed that his was a quadriplegic cerebral palsy [CP] case. We admitted him to a special school, and he was one of the most obedient students there. He fared extremely well in his studies. His observation skills and auditory abilities were outstanding,' his mother says.

He scored 82 per cent in his tenth and later graduated in public administration from Indira Gandhi National Open University (IGNOU). Vijaya says Sumesh has faced difficulties while writing public exams at various centres. 'In some cases, the scribes acted strange. Most exam centres had no lifts. We had to arrange people to carry Sumesh to the exam halls, sometimes climbing up to seven floors.'

Sumesh is silently listening to his mother, and when prompted, he decides to join the conversation. 'For minor issues, people go on strike these days. It affects a lot of people, and most cases go unnoticed. It pains me every time I hear about a strike or read about medical negligence. I am a victim of both. Kerala boasts of maximum literacy rate, but the people there behave worse than illiterates.'

He struggles a bit to complete his sentence but goes to convey an important message. 'If you want to protest, do it peacefully.'

Sumesh, now thirty-years-old, has been working

as an HR associate with a BPO. He gets picked up from his home at 7.30 a.m. and is dropped back by 8 p.m. His father calls him a zero-demand man who adjusts quickly to the circumstances. 'He was promoted last year, and the company also honoured him when he completed five years,' says Menon, who is currently working with the Composite Manufacturing Division of Hindustan Aeronautics Ltd.

Every month, Rs 4,000 from Sumesh's salary goes for various charitable activities. 'I want to support the education of poor children. That is my mission in life. I will help more people when I get a raise. I like to help people, and I want to assist children with CP,' says Sumesh.

When asked about his favourite pastime, Sumesh looks at the marriage portrait of his younger brother, Sujesh Menon, now working in the US. 'I love sitting in the front seat of my brother's car and going for long drives. I love travelling and reading.'

Sumesh is an avid cricket enthusiast, and it is tough for him to see India lose. His mother says Sumesh even skips his dinner if India loses a match.

His role model in life is his late grandfather. 'He had a huge impact on me. The kind of confidence he gave me made me a different person. He is my hero. He told my mother that though I may never walk, I should be made to stand on my feet and be independent.'

Sumesh uses a motorised wheelchair, which helps him move around more independently. He strongly feels that technology should come to the aid of special children and wants all the public places in India made user-friendly for special people.

'We need to create awareness. Otherwise, it will be difficult for people like me to enjoy life. Can you also write about young boys and girls smoking? I am aware that if women smoke, it can affect the child she gives birth to,' says Sumesh.

Vijaya says that the maturity level of his son has always impressed her. 'I am really lucky to have a son like Sumesh. He is the king of this home.'

King he is indeed, for not many can reign supreme, overcoming hurdles as mighty as the ones he has faced.

'I still can't take the pain my girl is suffering every time she fractures a bone. When the doctors told us that there is no medicine, we were left with no option but to turn to God. But I am happy that because of her, we met so people in life. Thanks to her, we even travelled the entire breadth and length of this country.'

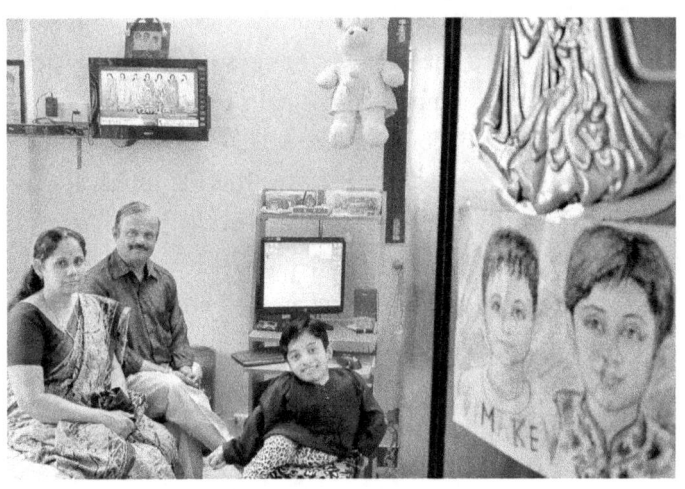

Unbreakable Will

Dhanya Ravi. Fate may have fractured all her bones but not her determination.

Kuppathil Ravi, sixty-one-year-old retired employee of Bharat Earth Movers Limited (BEML), used to keep a close tab on all the fractures his daughter Dhanya's body bore,

until recently. He says he has counted 310 fractures and later stopped doing so as it has been a painful experience.

Dhanya is twenty-four years old, suffering from a very rare disorder called osteogenesis imperfecta (OI), also known as brittle bone disease. A congenital disease, OI is caused by the defect in the gene that produces type-1 collagen, an important building block for bones.

Dhanya's birth star is Magha, which, according to her family, is auspicious for a girl.

'The delivery was normal, but the baby cried non-stop. Doctors suspected that she was doing so due to body ache and administered a medicine for pain relief. Due to her ill health, we could not conduct the twenty-eighth-day naming ceremony, which was later held on the fifty-sixth day of her birth,' says Ravi, a social worker. (In the Indian state of Kerala, during the naming ceremony, a black thread and gold chain called an *aranjanam* are tied around the baby's waist on the twenty-eighth day.)

During the naming ceremony, Dhanya was restless and cried continuously. She was taken to a doctor at the St Martha's Hospital. The doctor noticed a fracture on her thigh, and that was the beginning of an extremely painful journey for the child.

'To date, we have visited over twenty hospitals in India and consulted over fifty orthopaedic doctors. We also switched over to Ayurveda for some time, but her condition remained the same. In the last five years, we have stopped visiting hospitals,' says Ravi.

Dhanya is just over a foot tall, and her body is twisted. In the last twenty-four years, every fifteen days, one of her bones gets fractured. 'We feel terrible when we learn about

Precious Souls

another one of her fractures. These days she has stopped telling us about it. She rests for a couple of days, and it helps her recover after a fracture. Seeing Dhanya's condition, a few doctors have stopped taking consultation fee from us,' her father tells us.

Her mother, N. S. Nirmala, was delighted to have a girl child. 'She was the first girl in our family born after many years. She was very beautiful right from her childhood. She had delayed milestones and started speaking only at the age of four. Everyone loved talking to Dhanya,' says Nirmala, a housewife.

According to her, Dhanya never had any formal schooling but got tutored by her neighbour Victoria. 'She used to borrow books from her friends and come home to teach Dhanya. She ensured that my daughter got good basic education despite her being a mother of four girls.'

Victoria taught Dhanya till eighth-standard syllabus, and the little girl showed great interest in all subjects. 'I always wanted to do something for Dhanya, and I felt the best thing I could do for her was to teach her. She is a very intelligent girl. I used to teach her one hour every day. She would complete all her homework on time. I am happy to see her doing her bit to society despite her pains and struggles,' says sixty-six-year-old Victoria Macwana.

Amid a battery of electronic gadgets around her, Dhanya is all ears, and she takes over the conversation from Victoria.

'So I didn't go to school, but I studied. After Victoria aunt's

classes, I would do my homework. You know, I take life as it comes. I don't really have big dreams, but I do have small wishes to realise. My elder brother Rajesh is an engineer, and he got me a computer. He gave me the freedom to learn computers the way I want. He was particular that I learn all by myself,' says Dhanya, resting her back on a pillow.

Dhanya became adept at using computers, and her tryst with the virtual world began since then. Her online searches had helped her explore the world of music. "I really believe that music heals me. I am a big fan of Yesudas, and I am lucky to have occasional interactions with the great singer,' she says, and adds: 'My bones fracture if I do anything that requires physical exertion. I often get something called air cracks even now, but I am used to it. When a bone breaks, it usually takes two to three months to heal.'

She says the doctors cannot put any kind of rods or plaster to heal her fractures as these factures happen way too often.

'Everything in my body is twisted, and it is impossible to set them right. But nothing stopped me from doing what I wanted. At the age of twelve, I began my first job as a content provider for an online music group. My job was content editing for the site, and I gave the complete database [credits] of each and every song that came my way. I have given the credits to over 7,000 songs so far,' she says. She also designs e-cards, which earns her some additional pocket money.

In 2000, Dhanya, along with her friends, raised Rs 30,000 for a boy suffering from OI. 'I knew I had a role to play, and this fundraising experience got me closer to charity work. Soon, with the help of my friends, we registered a trust

[www.amrithavarshini.org] for OI cases, and today, there are eighty members. I coordinate events for the trust and also distribute Rs 500 to sixty-five members every month,' she says.

Today, Dhanya has her own blog (www.bizmermaid.wordpress.com), and she also promotes talented kids with OI. From jewellery designs to bags to umbrellas, Dhanya's team makes their presence felt in a silent way. She firmly believes that a special child can do wonders with proper family support and motivation, and according to her mother, Dhanya is a walking encyclopaedia.

'I still can't take the pain my girl is suffering every time she fractures a bone. When the doctors told us that there's no medicine for OI, we were left with no option but to turn to God. I am happy that because of Dhanya, we met many people in life. Thanks to her, we travelled the entire breadth and length of this country,' says Nirmala.

Dhanya needs support to move from one place to another, and she can be handled only by a few people. Most people are scared to carry her, fearing that she may have another fractured bone. When the family travels, Dhanya is placed on a pram.

'Inside the pram, I feel like a baby. I don't stop thinking about my mission. I want to spread awareness about OI. I am looking for an online job. I want to put smiles back on the faces of those suffering from brittle bone disease. I will. I know I can,' she says.

She sure will, and her will to make it happen is so strong that nothing can weaken her.

'Awareness about autism is still low in India. There are many schools which offer facilities for children with autism, but it is important for parents to pick the right school.'

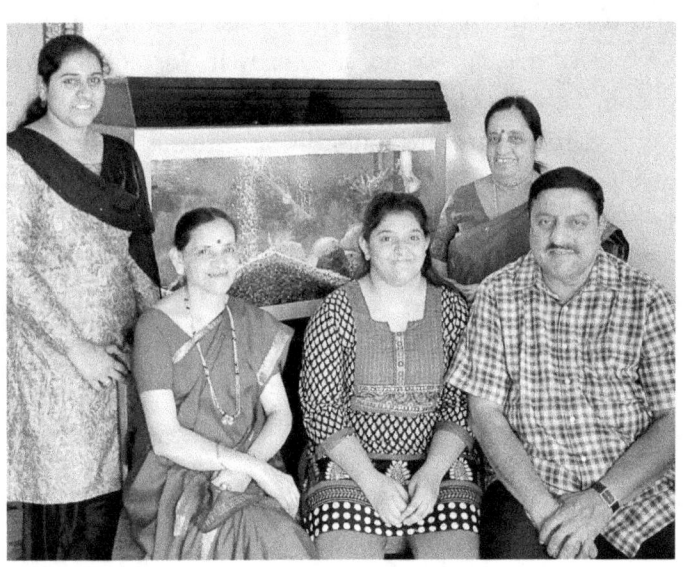

Finding Life

Prarthana R. Chandra. She paints, she dances, and she runs fast, but she has never painted a gloomy picture, never danced to a sad tune, and never ever ran away from disappointment.

Prarthana eagerly awaits her birthday every year; she knows it is the day that her toy collection will go up. The house

of this eighteen-year-old girl, an autistic fourth-standard student of Baldwin Opportunity School, looks much like a toy store with neatly stacked-up near-life-size dolls and toys.

Her father, N. Ramesh Chandra, is a superintendent of police and shares a special bond with her. 'It was a Caesarean delivery, and her weight was normal. She was a very pretty baby. At the time of her birth, her elder sister was just one year old. Prarthana was fine till the age of two, and later, we noticed that she was not sleeping well. We took her to a doctor,' her father tells us.

For the next three months, Prarthana was under medication to get proper sleep. However, the baby always looked drowsy, and the parents took the opinion of another doctor.

'For the next seven years, she was on medicines. I remember she stopped walking completely after undergoing the medication prescribed by the first doctor. As a kid, she always played on a carpet and would never come out of it. She often dozed off for a fraction of a second, and I knew something was not right. It was tough for me to hear that my daughter is autistic. I hoped that she will become normal,' her father recounts.

The turning point in Prarthana's life was when her father's close friend Sathyanarayana, now a retired deputy superintendent of police, suggested to the family to admit the girl to Baldwin Opportunity School. 'It was a bit awkward on the first day. She was totally clueless initially, but in the last ten years or so, a lot has changed for her. She learned many things at the school,' Ramesh says.

He says it requires much patience to bring up a special child. 'They change gradually. We cannot expect any

miracles. In Prarthana's case, she did not know how to ask for food when she was hungry, and it took us some time to understand her needs. We watched her closely and patiently.'

According to Ramesh, it is important for parents with special children to choose the right kind of school. 'Awareness about autism is still low in India. There are many schools which offer facilities for children with autism, but it is important for parents to pick the right school. Initially, it was difficult for me because Prarthana was not eating and sleeping properly. But life has become a lot easier now,' he says.

Prarthana's mother, Geetha, a housewife, is suffering from acute diabetes. Geetha says her daughter helps her with chores like cutting vegetables, drying clothes, and even vacuuming the house.

'She can't manage the kitchen alone, but she is always willing to help me. Prarthana is a good painter too. She loves running and had bagged many medals during the Special Olympics in category 2,' says Geetha. 'She dances very well,' says the mother as she bursts into laughter, telling us about her daughter's unique dancing style.

Hemalatha Muralidhar, Prarthana's aunt and a retired employee of BMS College of Engineering, hopes that the pretty girl will be okay one day. She says the girl is very caring. 'Once, one of our drivers fell sick, and Prarthana

insisted that we visit him. On the way, we stopped at a temple. On reaching the driver's house, Prarthana was quick to tell him that she prayed for him and he would recover soon,' Hemalatha recalls.

Prarthana loves the company of Moni, their Persian pet parrot. Prarthana's list of toys is endless, with Pappu, a chimp, being her favourite. A violet doll, Parli; a teddy bear, Pinky; and a tiger named Huli are her close companions. 'Pappu is always with Prarthana, except when she takes a bath,' says Keerthana, her elder sister. Prarthana even made several attempts to carry some of her toys to school.

Most of Keerthana's friends are Prarthana's friends as well. 'She hurts me sometimes but starts crying immediately after she realises that she has done something wrong. She is extremely sweet, and I never feel that she is a special child,' says Keerthana.

Prarthana too joins the conversation. 'My best friend is Shafaq, and she is in Kashmir. Shafaq, my best friend. Shafaq, my best friend,' she repeats.

The family is confident of making Prarthana self-sufficient. 'I don't want my daughter to be a burden on anyone. I hope she will get some job in the future,' says her father.

For Prarthana, the future surely belongs to her, as reflected through her positive outlook towards life.

'If you have a special child, you need to be self-motivated to overcome the pain. You have no other choice but to accept and move on.'

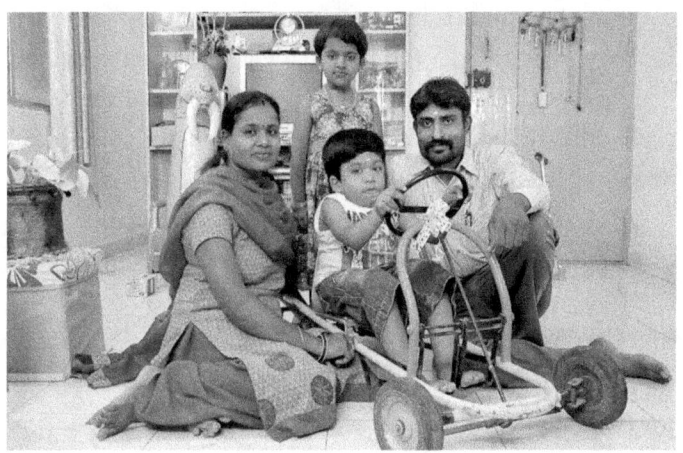

Happy Hope

Purushotham Reddy. Happiness is not just a name for him; it is his whole self.

Purushotham's parents fondly call him Happy as the boy always smiled at everyone when he was a toddler.

Happy is busy painting when we visit him. His father, H. Balakrishna Reddy, works as a commercial manager with DTDC, while his mother, Anitha N., takes care of Happy and his younger sister, Purvika Reddy. Happy is a second-standard student of Diya Academy of Learning.

He is diagnosed with one of the rarest disorders called mucopolysaccharidosis (MPS type IV, or MPS-IV), caused by the absence or the malfunctioning of liposomal enzymes needed to break down molecules called glycosaminoglycans—long chains of sugar carbohydrates in each of our cells that help build bone, cartilage, tendons, corneas, skin, and connective tissue.

People with MPS have permanent, progressive cellular damage which affects appearance, physical abilities, organ and system functioning, and in most cases, mental development. Happy has already undergone two surgeries.

When the boy was about to turn one, his father noticed a bend on his back and took him for a medical examination.

'We took him to an orthopaedic doctor, and we were told that he is having calcium deficiency. For six months, he was administrated calcium syrups. We went for a review to the same doctor, and after having Happy's X-ray taken, we were informed that it was not a calcium-related problem. Most of the doctors are clueless about these rare diseases, and they often do guesswork,' says Balakrishna.

Later, the boy was referred to a neurologist, who ruled out any neuro issue. He, in turn, wanted the parents to meet an orthopaedic doctor. At another hospital, the boy was shown to the genetic department since Balakrishna married from within the family (his uncle's daughter).

'Finally, we got him diagnosed at MediScan Hospital in Chennai in 2008. It was here that we were told about MPS and the different branches of disorders under it. Happy's blood samples were sent to the UK, and it was confirmed he was a case of MPS-IV. Further medical exams revealed that his spinal cord was compressed.'

In 2009, doctors suggested that the boy undergo a surgery for the spinal cord issue, but the parents refused, fearing for the boy's life.

'We weren't confident, and we waited for a year and took the opinion of doctors at CMC [Vellore], NIMHANS and HOSMAT. Later, he was operated on at Kanchi Kamakoti Child Trust Hospital in Chennai in 2010. The compressed spinal cord was removed, and a clip was fixed in its place. It was one of the most difficult periods in our lives,' he says.

Six months after the operation, a bend appeared below Happy's right leg. Medical examinations revealed that the area surrounding his right leg stopped growing. 'In December 2013, we had to operate his right leg to put a clip. Today, my son has a bulging chest, also called pigeon chest. He has mild breathing problem. There's no medicine available for MPS-IV in India. I have so far spent over Rs 5 lakh for Happy's treatment,' says Balakrishna.

Happy's mother says the family has had a tough time in the first four years.

'If you have a special child, you need to be self-motivated to overcome the pain. You have no other choice but to accept and move on. We have been visiting temples and hospitals—both these places give us hope. It is important to keep your hope alive. When the second child was on the way, we ensured that the baby was free of similar ailments. Even her blood samples were sent to the UK for tests,' says Anitha, a housewife.

Happy loves riding on his improvised pedal car, which also doubles as a physiotherapy machine so that his legs get some strength. The boy has asked his father to get the car modified with an additional seat for his sister and wants it covered from all sides. Happy also loves painting and photography. The boy is tech-savvy and has a laptop loaded with his creative outputs.

Today, Balakrishna is actively involved with the Lysosomal Storage Disorders Support Society (LSDSS), a parents' movement to bring awareness about rare diseases.

'We support families who are like us. We cried for many years, but we realised that tears won't take us anywhere. I decided to join hands with LSDSS to spread the awareness. Nobody knows the actual cause of these disorders. Lack of awareness is one reason the treatment is expensive. The hospitals make us do all types of tests, and they also refuse to accept a test done by another hospital. I have seen it all,' says Balakrishna.

He strongly recommends for people not to marry from within the family. He also feels that the schools should not chase away parents with special children.

'Do not marry any of your relatives as the chances of having a special kid are higher. Schools need to come forward and give us a chance. In one year alone, Happy was denied admission by six to seven schools. We are not asking schools to give any special care to these kids. We are not demanding any fee concession. We only want a chance to educate them. Finally, I hope the doctors will update their knowledge levels,' says Balakrishna.

In the prevailing mess of ignorance in our systems of living, Happy knows nothing else but to remain his namesake.

'There were times I played the dual role for him. Everyone was showing love and sympathy towards the kid, but I had to strike a balance between love, discipline, and principle. I am glad I did it.'

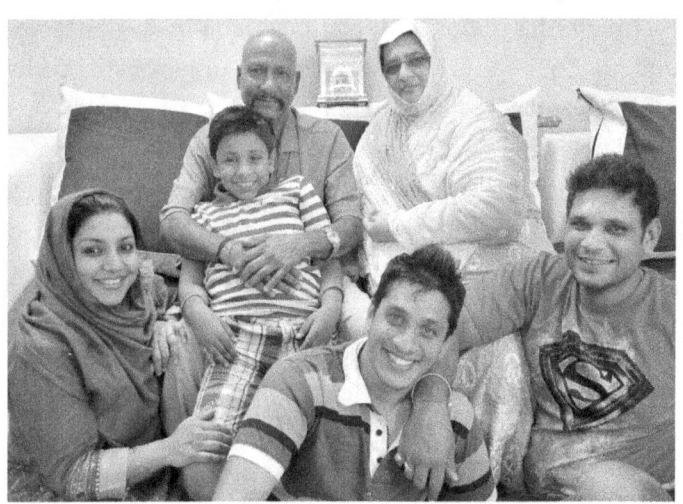

Conquering Challenges

Syed Hyder Ali. In water he found life.
In life he found affection. And his sense
of love has wafted across all.

Nine-year-old Hyder is waiting for the *Precious Souls* team along with his father, Rizwan Ali, near their apartment. As soon as he spots our camera, Hyder grabs it and starts shooting at will. He seems to enjoy every frame he captures.

As we settle down for our conversation, Hyder shifts his focus on yet another one of his passions—a laptop loaded with religious songs. A photo of former Indian wicketkeeper Syed Kirmani, his maternal grandfather, is his wallpaper.

Hyder's mother, Nishath Kirmani Ali, a special educator, begins to tell us her son's story. 'Hyder was born on 30 August, 2004, and it was a normal delivery. He was born on Imam Ali's [Prophet Muhammed's son-in-law] birthday, and we Shia Muslims consider it an auspicious day. His speech was delayed until he was three.'

The family was settled in California, and when Hyder was around four years old, Nishath lost her husband, Syed Faaqer Ali, a software professional and son of former Indian cricketer Syed Abid Ali.

'He suffered a heart attack while playing cricket. He was only thirty-four then. Soon after his death, I came back to India in 2008, but fate dealt another blow to me when Hyder was diagnosed with pervasive developmental disorder not otherwise specified (PDDNOS), which falls under the umbrella of autism spectrum disorder. I was really disturbed. I was only twenty-five years old then,' says Nishath.

Hyder's illness forced Nishath to get back to the US in search of better medical treatment. 'I didn't know anything about autism, but I got him the best medical help available in the US. In 2010, I came back to India on a vacation, and it was during this time that Hyder developed the phobia of flying,' Nishath recalls.

When they were to leave for the US via Hong Kong, Hyder refused to board the flight from Hong Kong to California, and they were offloaded thrice from the aircraft. 'It was a long wait of over twelve hours at the airport. We

had sedated him, but he woke up just before the take-off. The flight had entered the runway, and it was brought back after Hyder created a scene,' she says.

At Hong Kong, Nishath was joined by her father (Kirmani) and brother (Sadiq Kirmani), who sought the help of a paediatrician. He was administered sedation drops, generally given to children before surgeries.

'It worked, and we flew back to India, and Hyder woke up only after reaching back India. He was happy to be home. Our next mission was to find a school for him, and that was tough. We found a centre for therapy sessions and assessments and later shifted him to Kara 4 Kids. It was difficult for me to gauge his focus. He did better when he was put in a group,' she says.

In 2011, Nishath enrolled herself as a special educator course in autism and completed it in 2013. During this period, she met Rizwan, a fitness trainer and swimming coach, at the Hockey Club. 'Rizwan had a good rapport with Hyder, and it was amazing to see right from the first day how they jelled. We both clicked well,' she says. She was keen on Hyder not being deprived of a father's love, which made her consider Rizwan's proposal and later marry him.

Rizwan says he was impressed with Hyder's ability to stay under water for a long time. 'He is a very good

swimmer, and initially, he was not getting trained under me. But I realised that he loved water and swimming. He used to sing religious songs with much fervour. We connected instantly. Later, I came to know more about the family and decided to marry Nishath,' says Rizwan.

According to Rizwan, Hyder's ability to focus increased after his sustained swimming sessions. 'He gets me water and joins me for archery sessions at home. I expose Hyder to all activities. You should never keep a special child at home. Do not isolate these children, fearing that they would embarrass you. Do not be worried even if they throw a tantrum. They are no different from us. It is important to remember that autism is not a disease,' says Rizwan.

Within a short time, Rizwan understood the strengths of Hyder, and this helped him in shaping his son's future. 'Hyder sings well, he is obedient, he has a good geographical sense, and he is gifted with a super memory. He knows all the ninety-nine names of Allah, and he can also read a bit of Arabic. He loves the Kaaba, and we have taught him to offer *namaaz* [an Islamic way of worship],' says Rizwan.

Soon, Syed Kirmani joins the conversation. 'Media should play a big role in spreading awareness about special children. Unless the media focuses on these children and their families, the misconceptions surrounding these health issues will continue to thrive,' he points out.

According to him, when he discovered that his grandson was autistic, he was emotionally shaken. 'I wasn't expecting it. I used to sulk and thought that the Almighty was testing me. Then my social engagements exposed me to children who are suffering from worse situations. I consoled myself. Never get stumped by the crises in life. I overcome them

with a smile,' says Kirmani, who was adjudged the best wicketkeeper during the 1983 Cricket World Cup.

Nishath says the support she received from her parents was crucial.

'My trust in the Almighty never went down. My father and mother and the entire family stood behind be. There were times I played the dual role for Hyder. Everyone was showing love and sympathy towards the kid, but I had to strike a balance between love, discipline, and principle. I am glad I did it,' says Nishath while showing some of her priceless possessions, including Hyder's first teeth that fell and the hair from his first haircut.

Though Hyder may not know his value to those around him, it is evident that he is the storehouse of happiness in his small territory.

Part III

Photojournalist Jithendra's unique knack of connecting with special children reveals itself in the essence within each photo.

Capturing Precious Souls

Jithendra M.

'It's going to be just another shoot!' That was what I thought when I was given the *Precious Souls* assignment. I hardly expected it to be different from any of my other assignments—shot and forgotten. Besides, I didn't have the faintest idea that I would be shooting for the entire series, because that was not how it worked in a newspaper.

That was how it began. As I started shooting *Precious Souls*, I began feeling that this wasn't just another assignment. It was perhaps more rewarding.

Everything about *Precious Souls* was different and unique. I believe it was the first time ever in a newspaper that the promos of articles to be featured were uploaded online in the form of videos. As I began working with Ananth Sir for the series, I realised that it was possible to develop an emotional connection with your subjects.

Capturing precious children is barely a cakewalk. Most of the time, these children are fidgety and curious. There were times I had to follow my subject for quite some time to get that one perfect shot. There were instances when I was afraid that some of them would possibly damage my camera, as they wanted to explore it.

Shooting Ragini was special and easy; she was more than willing to be photographed, and her face glowed when I showed her the pictures that I shot.

A subject asking the photographer to pose with her/him is certainly uncommon if not unheard of. I was pleasantly surprised when Dhanya asked me if I could pose with her for a photo. This was indeed a rare, memorable moment.

One of my toughest *Precious Souls* assignments was shooting Shashank. This was the first time after I began clicking for the series that I had to go alone for the shoot. Various permissions had to be taken as the shooting had to be done in a pool. The boy wouldn't pose for me; he kept on swimming. There was also the issue of low light. I clicked about fifty photos and was lucky that one of them came well.

The photograph that touched my heart was Sheeba's—especially when his father was carrying her, waiting for us inside their two-room house. The photograph I liked most in the series was Kedar's. It was different because instead of the parents, it was his cousins who posed with him, and it was one big happy photo exuding much energy.

As I began shooting for *Precious Souls* regularly, I started receiving plenty of compliments from my photographer friends with other newspapers. In the competitive media sphere, it is hard to get appreciation from others in the same field.

Precious Souls

This picture by Jithendra comes alive with the life of Sheeba, who is diagnosed with rickets and is twenty-eight years old. Her father is a vegetable vendor.

One of my biggest compliments came from my elder sister Sandhya, who works as a librarian in a college. She told me she loved the articles and the photos. She subscribed to the newspaper for the college and used the stories featured in the *Precious Souls* series to inspire students in the college.

I was pleasantly surprised when one of the special children I shot, Purushotham, recognised me at a protest site months after I clicked his photos. He came up to me and greeted me. I was amazed by his extraordinary memory power. I was also extremely delighted because I knew I had established an emotional bonding with my subjects in this series.

One of the things that amazed me was Ananth Sir's ability to ask the right questions and elicit the answers without hurting the sentiments of the parents of these

children. It is hard to ask certain questions without the parents being offended, but Ananth Sir managed to do this. He ensured that their sentiments and concerns were respected when being interviewed, a quality that is hard to find in journalists today.

These are for twenty-four assignments, twenty-four photos that are going to stay with me for a long time. They are courageous tales of love, sacrifice, patience, and perseverance. These are stories of people who have dared to defy limitations and chased their dreams and of others who have tirelessly accompanied these brave hearts.

Shooting *Precious Souls* has been a memorable journey and a great learning experience. I wish that the series had continued, with stories of people, whose limitations didn't restrict them to inspire thousands of others, reaching many readers.

I am grateful to my chief photographer and newspaper for reposing faith in me and allowing me to continue shooting for the entire series. I am sure, in the book form, with many new chapters added, *Precious Souls* and its images will inspire many to move beyond their limitations and pursue their dreams.

Jithendra M. is a thirty-four-year-old photojournalist with *The New Indian Express*. Hailing from Kota near Udupi in Karnataka, he has been shooting photos for various media houses for the past fifteen years. He is passionate about travel photography and has also worked as an assistant cinematographer for the Kannada movie *Giri*, released in 2005.

A Metaphor for Triumphant Lives

Simmi Santha

If you are reading this, you are probably on board your best reading ride of a genuinely inspiring and information-packed book. Written in an easy-to-understand language, *Precious Souls* introduces you to twenty-four sparks of inspirations, their journeys, and their equally inspiring families.

Many of my friends and I here in Canada and others in India, USA, and UK have been ardent followers of the refreshing stories of *Precious Souls* since its inception. Although we have come across inspiring stories of differently abled individuals in several books, we have not come across so many stories all in one place.

The media is indeed a great platform to spread awareness about people with special abilities, and in this case, it is utilised very well to serve this purpose. Many of us will eagerly wait for the new story and discuss the clinical aspects of each condition. To be able to read twenty-four true stories in a short span of less than one year is indeed a treat. The cherry on the top is the beautiful pictures and the enchanting videos posted online.

Each story is so captivating that as we rejoice in their moments of triumphs, it feels as though we are witnessing the moments of challenges and the process of finding solutions by the individuals and their families. To date, the stories are fresh in my mind, and I continue to draw inspiration from them. This book certainly is the only one of its kind, overflowing with inspiration.

While *Precious Souls* has successfully spread awareness on different abilities of its subjects, it has also served as a tool in educating the reader on the importance of early intervention and has introduced them to several strategies and aspects of treatment. It is a one-stop shop for ideas on how to deal with a particular condition (at least the ones that have been covered in the stories), what strategies parents have already tried, what has worked, and what has not.

It enlightens the reader about the possible risks to children from marriages of consanguinity; the importance of early and right kind of intervention; the importance of acceptance of family members; the dangers and side effects of medications; the phobias, fears, talents, thoughts, and words of the differently abled; and the significance of a social support system.

What stands out is the indomitable spirit of the individuals with special needs and their family members, who do whatever it takes to support them. It is very easy to become judgemental and prejudiced about an individual's condition and the manner in which he or she and the members of the family deal with it.

However, it is only the people undergoing the challenges who truly know what they have faced or continue to face. This book has served as a platform to make the reader aware and appreciate the actual perspective of the individual and the family.

Additionally, I was intrigued by the extent of relevant information related to each condition that the author has meticulously provided in each story. *Precious Souls* has not only enlightened me on some medical conditions that I lack in-depth knowledge of but has also provided me with ideas on how to manage the condition in a very easy-to-understand language.

While every story is commendable, I have been particularly blown away by Dhanya's story. I have absolutely no words to describe Dhanya's spirit of overcoming challenges. She and all other precious souls in the book are indeed living proofs of the adage 'Where there's a will, there's a way'.

Simmi Santha is a senior behaviour therapist currently working with a psychological firm in Canada. She has been in the profession of special education and rehabilitation sciences for the past twenty years. A graduate from NIMH, Secunderabad, Simmi shifted to the US in the year 1998 and then moved to Canada in 2008.

The first recipient of Reeta Peshawaria Menon Fellowship award, she has authored *Understanding Autism: A Manual for Parents and Caregivers of Individuals with Autism Spectrum Disorders*. She was instrumental in setting up Reeta Peshawaria Centre for Autism and ABA Services in Kerala. The author can be reached at simmi.rpc@gmail.com.

My Experiences with the Special Children

Sujatha Sriram

I was twelve years old when I first saw a special child, a girl about seven years desperately trying to convey something to a shopkeeper with her gestures and facial expressions. The shopkeeper was impatient and refused to attend to her. The girl couldn't speak and had a mild hearing impairment.

Despite feeling sad for the girl, I knew there was hardly anything I could do for her. Perhaps it was this helplessness

that acted as a catalyst in my decision to assist people with special abilities.

The decision took a definite shape in 2003 when I left the corporate life and joined a counselling course and later moved into special education and yoga therapy for children with special needs. Having good interpersonal skills, I didn't find it difficult to connect with special children or their parents.

In 2005 I began teaching special children but soon found that it wasn't an easy task. There were many kids with special abilities, each unique, needing different level of care and attention. There weren't many options except to let go of the inhibitions and fears and devote time and energy to each of the special children.

When being with special children, it is hard to be emotionally detached from them. I too got attached to a three-year-old autistic child, Sriharinarayanan, but there was always this feeling of not being able to do enough for the boy. Spending a lot of time with the boy to the extent of being his shadow and even imitating his action paid off finally, and the boy got admitted to a regular school as his socialising skills improved drastically.

When dealing with children with autism, it is important to give them plenty of positive reinforcements. They also need constant breaks from regular activities because of their limited attention span. Such children should be offered the facility to have exams written with the help of computers instead of the usual written exams. Besides, the syllabus should be tweaked to fit their needs.

It is also important to understand the unique talents special children are endowed with. Jayaprakash, a

fourteen-year-old special child, was shy, with limited speech and reading skills. However, he could tap well with his hands.

I was able to link this to Howard Gardner's multiple intelligence theory and asked his parents to enrol him for drum classes. The boy became more functional, with improved academic and socialising skills, after he was introduced to reading, calendar skills, and the concept of money through the names of various drums, time of concerts, and remuneration he gets for playing.

While helping special children grow and be more functional, it is important to be patient and to respect their identity. Parent support groups, regular parent–teacher meetings, modified curriculum, and understanding multiple intelligences and synchronising it with learning styles are also vital. Above all, it is important to have faith in the children.

Many people have preconceived notions about the abilities and disabilities of special children. A lot of awareness needs to be brought in among people so that the special people are better understood and accepted and the regular schools open their doors to them. Social media is the right platform to do this, and *Precious Souls* has brought about a huge difference in the way people perceive children with disabilities.

Although a lot of technical information on various disabilities is available on the web, it is important to portray the human face of these details. Hats off to the dedication, commitment, and attention to detail evinced by Dr Anantha Krishnan in bringing the stories of these brave souls to the readers.

My friend Meenakshi Kulkarni was overjoyed after her son Kedar, a child with cerebral palsy, studying in a regular college, was featured in *Precious Souls*, and Kedar was happy as well. Meenakshi felt that being featured in the book was a testimony to her successful parenting.

I hope this book helps in the process of the society becoming more inclusive so that people with different abilities do not feel left out. Let's hope for change and for a better tomorrow.

Sujatha Sriram is a postgraduate in special education for persons with multiple disabilities and has completed a *transdisciplinary* course on multiple disabilities for children with neurological impairments. She is a special educator, counsellor, trainer, and yoga therapist based in Chennai. The author can be reached at sujju69@gmail.com.

The Last Word

Serving Special Children
Is Like Serving God

On 9 July 2015, I had a one-to-one with
one of India's young spiritual leaders,
Sadguru Sri Sharavana Baba. When I told
him that I was almost in the process of
finalising *Precious Souls*, he said, 'We
must all see God in every special child.
We should take care of them gently as
if they are still in the mother's womb.
We must establish an emotional connection
with these children. When you worship an
idol, you actually get nothing, but when you
establish an emotional connection, then the energy
flow happens to and fro. We should understand
the world of special children. Our service has
to be selfless. We need to get the blessings of these
inspiring souls. Serving them is like serving God.'

Dr Anantha Krishnan M.

Part IV

About the Author

Dr Anantha Krishnan M.

Dr Anantha Krishnan M. is an award-winning aerospace and defence journalist. Born to teacher parents in Kerala, he strayed into journalism at the age of nineteen after leaving an engineering course midway in Latur, Maharashtra.

Anantha Krishnan, who holds a doctorate in journalism and communication from the University of Mysore, began his career with Pan Media Features (Hyderabad) under the tutelage of veteran journalist K. Sathyapal Menon in 1992. Since then, he had worked with the *Citizen's Eveninger*, *Deccan Chronicle*, *The Times of India*, Hindustan Aeronautics Limited (HAL), *Aviation Week*, and *The New Indian Express*.

In 2005, at the age of thirty-two, he was appointed the official spokesperson of HAL, becoming one of the youngest to hold such a post in a Ministry of Defence undertaking.

He is the brain behind former Indian President Dr A. P. J. Abdul Kalam's dream e-paper *Billion Beats* and has been appointed its national affairs editor in 2007, a post he still holds. He is also a strategic adviser of the Dr A. P. J. Abdul Kalam International Foundation, headquartered in Rameswaram, Tamil Nadu.

Currently, he is a consulting editor specialising in aerospace and defence, contributing for a few media houses. He also anchors India's top-rated defence blog *Tarmak007*.

The author is the Founder and President of Inspired Indian Foundation, a writers' movement batting for unsung heroes.

Donning the suit of a life coach and motivational speaker, Anantha Krishnan launched Mission Parivarthan, a unique branding, communication, and image makeover programme for individuals, institutes, and corporates, in 2015. Parivarthan aims at helping people rediscover their inner strength.

He is married to Sindhu A., a physicist, and the couple is blessed with a son, Govind Sai Krishnan.

Precious Souls is Anantha Krishnan's second book. His first book, *A Different Spirit*, published in 2009, is a bestseller biography—which is into its sixth edition—of noted paraplegic Olympic athlete Malathi K. Holla.

The author tweets at @writetake.

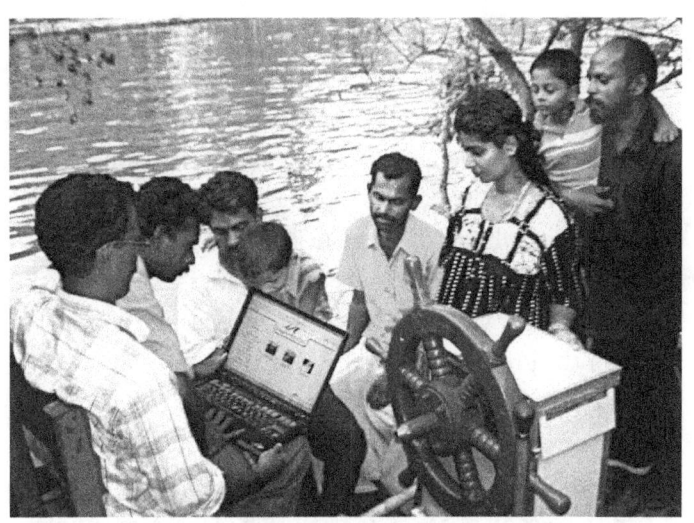

Inspired Indian Foundation

The Inspired Indian Foundation (IIF) is the brainchild of the author and a group of people who make a living out of writing. Most members work in the media and communications field with a passion and commitment to propel India's future flights, the underlined belief being 'If India has to change, *we* must change first'.

The soft launch of the Inspired Indian Foundation on 14 April 2008 was sans glitz, blitz, microphones, and speeches. Two boat drivers, Rajesh and Prashant, launched the foundation activities in the placid backwaters of Kerala as curious villagers looked on. Interestingly, Rajesh is a BA economics graduate who became a boatman to support his family.

In 2009, the Inspired Indian Foundation was registered under the Indian Trusts Act, with the charter of celebrating unsung heroes. Operating from a rented premise of one of the founding members in Bangalore, IIF launched its first project in 2009 with *A Different Spirit*, an inspiring biography of wheelchair athlete Malathi K. Holla. Since its inception, the IIF has kept its activities away from the publicity radar, with the sole aim of focusing on charity work on the ground level sans noise.

In 2014, at the first Annual Inspiring Indian Foundation Awards ceremony, ten achievers from various walks of life were honoured.

In the second phase of its expansion plans, a government primary school in Bangalore has been adopted under *Project Pathshala*. The foundation supports various needs of sixty children in this school.

In November 2015, the foundation took initiatives to relaunch Dr Kalam's e-paper, *Billion Beats*.

You Can Chip In

If you truly believe that we can alleviate the lives of unsung heroes, you can help us by donating funds to propel a noble cause. IIF strives to make a difference to the lives of a few people every month.

IIF does not accept foreign funds, and all donations should be in Indian rupees and through an Indian bank.

Inspired Indian Foundation account no: 67086716743, State Bank of Travancore (SBT), Indiranagar branch, Bangalore. IFSC code: SBTR0000679.

Donations to IIF are eligible for tax exemption under Section 80-G of the Income Tax Act of 1961. If you are making an online transfer, do drop in an email with your details, phone number, and complete address to help us send you the receipt:

sindhuananth@gmail.com or
sindhu@inspiredindianfoundation.org

For more details, visit:
http://www.inspiredindianfoundation.org/

Billion Beats

**Guru Kalam's Dream
to Capture the Pulse of India**

26 October 2007. The winter was just settling in on New Delhi then. People's President Dr A. P. J. Abdul Kalam was restless at his temporary residence at an army guest house. It was just over a month after he had demitted the Office of the President of India and was settling down in his all-time role—as a teacher. His official residence hadn't been allotted then.

Guru Kalam, who was by then undoubtedly the 'king of hearts' to billions of Indians, was concerned about the overdose of negative reports in the media. As always, he was seeking a solution to the issue.

'You see, you fellows don't care for the younger generation,' he told, in his inimitable style, a group of communication professionals and journalists who had called on him that night. 'Why don't we launch an e-paper that focuses only on positive stories about Indians?' he wondered, looking at this author.

His vision became a reality within two weeks when *Billion Beats* took birth. It was launched by Guru Kalam on 14 November 2007 (Children's Day) with over a lakh students witnessing the event in Karimnagar, now part of Telangana, a newly born South Indian state.

'*Billion Beats*, an e-paper aimed at capturing positive stories, is indeed a beautiful idea. It should set a new tradition by celebrating the success of Indians wherever they are. It may be from an agricultural village or a fishing village, it may be from a dairy village or from the service sector . . . *Billion Beats* should tap and spread the success of Indians and their glad tidings. We have islands of success in every field, and we should connect them to make a garland. I am confident that *Billion Beats* would create knowledge connectivity among the people,' Guru Kalam said during its launch.

The first nine issues of this e-paper were edited and designed from Bangalore, with the author leading as its national affairs editor. Later, in 2008, the editorial base was shifted to New Delhi, with the author ejecting out of the mission. But the periodicity thinned, and eventually, it went off the radar.

Just a couple of days before his demise, Guru Kalam told his family members about the inspiring concept adopted by *Billion Beats* and the need to continue it. Post his demise

on 27 July 2015, while launching Dr A. P. J. Abdul Kalam International Foundation in Chennai, his family members (House of Kalam, Rameswaram, Tamil Nadu) decided to relaunch *Billion Beats* on 14 November 2015—again on Children's Day.

Eleven-year-old Anushiya, a sixth-standard student of St Joseph Higher Secondary School and daughter of a fisherman from Verkottu near Rameswaram, handed over the first copy of the relaunched edition of *Billion Beats* to A. P. J. M. Maraikayar, the ninety-nine-year-old elder brother of Guru Kalam, bridging two generations.

The editorial operations of *Billion Beats* will be continued by Inspired Indian Foundation, headquartered in Bangalore. The digital issues will be uploaded on to www.inspiredindianfoundation.org and http://houseofkalam.org every month. The issues can also be accessed from the official FB page: https://www.facebook.com/BillionBeatsOfficial/.

Editorial contributions to *Billion Beats* along with your details can be emailed to billionbeats@gmail.com **or** billionbeats@inspiredindianfoundation.org.

The author has been reappointed as the editor of *Billion Beats* by House of Kalam during its relaunch. Trustees of Dr A. P. J. Abdul Kalam International Foundation are the editorial advisers of *Billion Beats*. A host of professionals from all walks of life, spread across all over the globe, will act as its virtual reporting team.

With the tagline *The Pulse of India*, one of the key digital initiatives of Guru Kalam, *Billion Beats* has again spread its wings.

And every Indian is invited to celebrate success the 'write' way!

www.ingramcontent.com/pod-product-compliance
Lightning Source LLC
Chambersburg PA
CBHW051521170526
45165CB00002B/563